Studio Techniques

for Advertising Agencies and Graphic Designers

Sharon Squibb
with David Squibb

A ROUNDTABLE PRESS BOOK

WATSON-GUPTILL PUBLICATIONS / NEW YORK

To my parents, Don and Joyce Squibb,
whose love and support inspire me always

A ROUNDTABLE PRESS BOOK

Directors: Marsha Melnick and Susan E. Meyer
Project Editor: Sue Heinemann
Editorial Assistant: Larry Dark
Cover Design: David Skolkin /Binns & Lubin
Interior Design: Jeff Fitschen
Typography and Computer Art: Brad Walrod/High Text Graphics
Line Illustrations: Ray Skibinski (except as noted)
Photographs: Sue Heinemann

Published by Watson-Guptill Publications,
a division of BPI Communications, Inc.,
1515 Broadway, New York, NY 10036

Library of Congress Cataloging-in-Publication Data

Squibb, Sharon
 Studio techniques for advertising agencies and graphic designers /
Sharon Squibb with David Squibb.
 p. cm.
 "A Roundtable Press book."
 Includes index.
 ISBN 0–8230–4939–6
 1. Advertising layout and typography. 2. Commercial art.
 3. Graphic arts. 4. Computer drawing. I. Squibb, David.
 II. Title.
 HF5825.S68 1991 91–7525
 741.6′7–dc20 CIP

PANTONE is a registered trademark of Pantone, Inc.
Macintosh is a registered trademark of Apple Computer, Inc.
QuarkXPress is a registered trademark of Quark, Inc.

PRINTED IN THE UNITED STATES OF AMERICA

First printing, 1991

1 2 3 4 5 6 7 8 9 10 / 96 95 94 93 92 91

Acknowledgments

For their invaluable help in putting this book together, I would like to acknowledge the following people. Many thanks go to my brother David, who shared his advertising and design talents. At Roundtable Press, grateful thanks go to Marsha Melnick and Susan E. Meyer for making this book possible, my editor Sue Heinemann for her knowledge and good humor, Larry Dark for his hard work, and Ray Skibinski for his elegant illustrations. I also thank Angela LaGreca for her patience as I sat hour by hour at her computer.

I would also like to acknowledge the many people who have contributed their time and expertise: Ilene Block for her insights about design and photocopied art, Mary Moriarty and Marc Sill for helping me with computers, Jerry Caggiano for offering his knowledge about animatics and video presentations, Nina Wintringham and everyone at Unitron Graphics for graciously showing me their Scitex systems, and Stephen Licare for sharing his knowledge of print production.

Specific credit goes to the following people who contributed their tricks of the trade to chapter 7: Ilene Block (rebreaking lines of type, positioning art with a triangle, special effects with photocopied art), Paul J. Collins (drawing parallel lines with a triangle, no-bleed color comps, homemade rubber cement pickup, drawing hands), B. W. Honeycutt (creating special effects with torn paper and ghosting, designing a grid, creating a dummy, photograph collages), Tony Liveri (checking stat sizes), Bill Previdi (simulating varnish, super-stick INTs), Karen Reed (creating special effects with markers on paper towels, correcting comps), and David Squibb (using plate bristol board, positioning large stats, using thumbnails for rough layouts).

Contents

Introduction

The nature of graphic design and advertising art has changed dramatically in recent years. Desktop publishing, telecommunications, and advanced printing technologies offer new possibilities for the world of visual communication. With electronic publishing, transmitting information and preparing copy and art can be as instantaneous as typing a command on a keyboard.

To remain competitive in this high-tech graphics industry, studios today are updating their techniques and equipment. More and more, the graphic artist is required to have both manual and computer skills. Not only must designers know how to draw a perfectly curved corner or to fit copy within a design, but they must be able to tell a machine to do the same thing.

While researching this book, I interviewed a number of art directors and designers who were traditionally trained and have spent their careers at the drawing board. I also spoke with a new generation of artists who work primarily on desktop systems. To the board artists, mechanical tools are old friends; they find laying down a piece of type or retouching an illustration by hand more immediate than clicking a mouse to perform these functions. The desktop designers argue that there is no replacement for the speed with which a computer allows them to reflow a type column or adjust a layout in some other way.

Although it is easy to get caught up in the debate about which is better, most designers agree that even today a suc-

cessful designer must have a solid knowledge of basic studio skills. Having the ability to use either a computer or traditional techniques is an important asset for any designer. Combining your skills, you might, for example, execute all the type design on a computer and even indicate holding lines for the art, but then paste up line art or position stats. Or you might manually paste in a last-minute correction using "scrap" type—without reprinting the entire page.

The goal of this book is to present a clear overview of the knowledge and skills needed to complete a printed piece. Much of this information is the same whether you are working by hand or on a computer. Both approaches, for example, require an understanding of the available choices in type selection and spacing; both also require knowledge of the available methods of reproducing art and how to prepare it for the printer. Even learning how to paste up a mechanical or comp a layout by hand can benefit the computer artist—there is just no substitute for the hands-on experience of handling type and getting a physical sense of the design. From the opposite perspective, it is essential that the traditionally oriented artist learn to use the computer—not only to be competitive but also for the experimental possibilities it offers.

This book is intended both as an introduction to the many options at your disposal and as a reference to the basic information you need for any design work. Use it to build your skills and improve your understanding of the diverse decisions that underlie all successful advertisements and designs.

1 Equipment and Materials

Advertising artists and graphic designers encounter a variety of work challenges requiring both fundamental and specialized skills. Whether you are doing roughs and comps or completing camera-ready art, speed and accuracy are key. To meet the industry's exacting deadlines and professional standards, it is essential to be closely familiar with the uses and capabilities of the tools and materials of the trade.

The equipment available to the advertising or graphic artist seems limitless, so it is important to consider the effectiveness of your tools in relation to the particular work you do. Build your toolkit selectively. Though you needn't break the bank when shopping for equipment, keep in mind that proven quality materials generally perform better than bargain brands. And with proper care, well-made tools last a long time.

New technology is continually providing the graphic artist with more and more sophisticated methods and materials. Some of the improvements can save you time, but you don't have to update your equipment constantly. In most cases you can get the job done with just a few basic instruments.

FURNITURE

Drawing Table and Board
The drawing table is the graphic artist's primary work surface, so it is important to choose a model that you are comfortable with. A range of sizes and styles are available, from the classic, wooden standard to a state-of-the-art pneumatically raised and lowered model. To accommodate different drawing, mechanical, or design needs, you should be able to adjust the tabletop's angle and height.

A drawing board can be used on its own or placed on the drawing table to preserve its surface. To ensure precise T-square work, it must have perfectly squared sides (this is not necessary if a parallel bar is used).

Taboret
This storage unit also serves as an organizer of artist's materials. The taboret should have utensil drawers, storage wells, and shelves to keep essential tools within easy reach.

Light Box
The light box consists of a frosted glass or plastic top held within a frame and illuminated from below by fluorescent tube lights. It can be used for viewing photographic slides and transparencies, evaluating them against color separations, tracing images from photographs or illustrations, and registering overlays. Many styles are available, from a mini-portable to a freestanding unit.

You can make your own light box by building a wooden frame to any dimension. With a table saw, cut ridges in the planks to rest a sheet of plexiglass or glass on. Wire two color-correct fluorescent tubes inside the box with an on-off switch outside. To reflect light to your artwork, place a piece of white paper under the box.

Flat File
A flat file is perfect for organizing and storing your work horizontally. Made of metal or wood, it usually consists of five-drawer units with inside drawer sizes ranging anywhere from 26×20 inches (660×508 mm) to 50×38 inches (1270×965 mm).

Lighting
Proper lighting is vital for the work area. You can use a simple hooded incandescent lamp with an adjustable arm or a more elaborate combination incandescent/fluorescent model. Both clamp onto your drawing board and allow you to direct the light anywhere you choose.

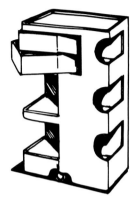

This taboret has wheels on the bottom and storage trays tha swing out for convenience.

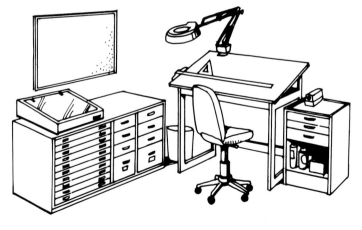

A well-organized studio has all the furniture a graphic artist needs within easy reach. Note the comfortable chair and adjustable light.

PAPER

Hundreds of papers with varying qualities are available. The most durable, long-lasting papers are acid- and lignin-free; they don't contain the natural chemical that eventually causes paper to yellow.

Layout Paper

A design studio staple, layout paper, which is semitransparent, is suited for everything from thumbnails to comprehensives, or final layouts. Its relative transparency makes it good for transferring type or images when you are doing hand lettering or tracing illustrations. Depending on your needs, you can choose an inexpensive bond or a 100% rag layout paper. For work with markers, use special marker layout papers, which don't let markers bleed through.

Tracing Paper

Lighter and less expensive than layout paper, tracing paper is commonly used in the rough stages of developing layouts. Its transparency makes it ideal for tracing fine details with pencil or pen. Tracing paper is also used to protect mechanicals, illustrations, and photographs; indicate color breaks; and mark corrections. Markers don't smear on its surface.

Vellum

Vellum is a more expensive, heavier, high-quality tracing paper, available in pads or rolls. It is used especially for ink renderings and illustration. An advantage is that mistakes can be easily removed with a razor blade. It is also ideal for overlays (page 19).

Illustration Board

Illustration board is the surface on which most art is prepared for print-ing. It consists of either coated or uncoated, rag or wood pulp drawing paper mounted onto stiff cardboard. The two basic kinds of board are smooth (hot-pressed) or rough (cold-pressed). Hot-pressed board is used for mechanicals and is ideal for finished art requiring clean, precise linework. In contrast, cold-pressed board, which has more "tooth," is good for wet media, such as water-color, airbrush, and acrylic.

Bristol Board or Paper

Bristol board or paper is a stable surface popular among designers for its versatility; it takes any medium from pencil and pen to liquid washes. Available in varying thick-nesses—called plies—bristol board comes in a high finish (smooth) for precise pen and ink or pencil draw-ings; a medium finish (rough front, smooth back) for a variety of media from pencil and pastel to airbrush, markers, and paint; and a rag finish for liquid and dry media.

Transfer Paper

Transfer paper works similarly to carbon paper. You can trace an image from one surface and imprint it onto another—for example, to transfer a rough layout or design to your final drawing surface.

Colored and Metallic Papers

Colored papers can be used to create three-dimensional displays, such as package designs, or to suggest a solid color background. Color-coded papers, keyed to specific printer's ink formulas, approximate what you will see when the piece is printed. Metal-lic papers are used, by the same token, to approximate metallic inks.

STRAIGHTEDGES AND TEMPLATES

T-Square

One of the most essential graphic design tools, the T-square enables you to draw precise parallel horizontal lines by sliding its head up and down along the left edge of the drawing board. Many drawing boards have T-square devices called parallel motion units, or parallel bars, which have cross-wire, counterweight, tooth-and-gear, or steel bearing systems that slide the straightedge evenly up and down the board's surface. Because they are fixed in position mechanically and won't go out of alignment, parallel bars are more accurate than T-squares.

Triangle

Used along with the T-square or parallel bar, a right-angled plastic or metal triangle helps you to render angles perfectly and draw perpendicular lines. The most common sizes are 45-90 and 30-60-90 degrees. An adjustable triangle, calibrated for angles 0 to 90 degrees, is very useful for detailed drafting, charts, graphs,

and diagrams. Inking triangles are available with raised outside edges that prevent the ink from technical pens from seeping underneath. Solid steel triangles have rigid edges that are ideal for cutting against. A steel-edge plastic triangle can be used for both inking and cutting.

Templates

There are templates to help you draw almost any geometric shape or illustrative figure from circles and squares to computer symbols and people, whether for layout purposes or for final art. Among the templates available are French curves and adjustable curves (which produce curving lines), lettering templates, adjustable triangles, circle guides, square and rectangle templates, technical templates (such as those for computer symbols), protractors, and ellipse guides. To prevent technical pens from smudging, the template should have beveled edges or an ink boss to raise it a bit from the drawing surface.

Templates like these are helpful in drawing ellipses, curves, and a variety of other shapes.

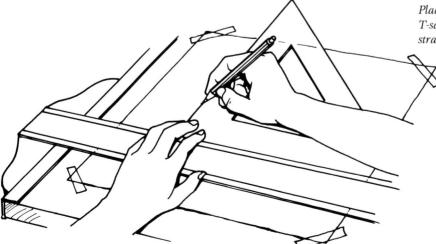

Placing a traingle against a T-square allows you to draw straight vertical lines.

TOOLS FOR PREPARING MECHANICALS

Cutting Tools

Scissors, paper cutters, mat knives, and graphic (X-Acto) knives are studio workhorses. *Mat knives* and *graphic* or *craft knives* consist of a rubber or metal handle with replaceable steel blades of many sizes and styles for specific jobs from heavy-duty cutting to intricate trimming to cutting stencils, freehand curves, and circles. *Single-edged razor blades* are good for making small cuts when doing mechanical work. Replace blades often to avoid slippage and ragged edges. *Circle cutters* are compasses fitted with cutting blades.

Scissors are timesavers when you are doing rough work. The most popular brand with designers is the anatomically comfortable Fiskar scissors. Also available are replaceable-blade, adjustable-blade, and ambidextrous scissors.

A *paper cutter* is a fairly basic piece of equipment for cutting art board and paper. You can use either a guillotine or rotary cutter. The guillotine cutter has a pivoting handle that makes straight cuts in one or many sheets of paper or board, while the more specialized rotary trimmer cuts single sheets of more delicate material such as film or other coated materials. Some rotary trimmers include a light box to guide you when you cut transparencies.

Measuring Tools

Proportion wheels are used for figuring the percentage change when reducing or enlarging photographs and artwork to fit a layout. They are made of two circular disks marked off in either inches or picas. *Calculators* also aid in calculating enlargements and reductions (you divide the size

you want by the size of the original). There are even models, such as copy-fitting calculators, designed for the graphic artist.

The 12-, 18-, or 24-inch (300, 450, or 600 mm) *ruler* is an essential tool for measuring, cutting, drafting, and designing. The three standard scales—inch, pica, and agate—are often found on one ruler. A heavy straight-edge ruler with nonslip rubber backing is ideal for cutting, while a hard, clear plastic ruler can be used for inking or lining up type. A *Schaedler rule*, on flexible, translucent plastic, is the most accurate for measuring. *L-rulers* and *T-rulers* can be useful for measuring sides at right angles. A *parallel ruler* helps you draw parallel lines at adjustable distances.

Line and *type gauges* include multiple units of measurement such as inches, agates, metric units, picas, and points. For example, *compositor's type scales* and *typographer's depth scales* are useful for measuring type and marking off line widths and column depths. A *Haberule* is used for measuring lines of type within a type column (see page 38).

Compasses

Compasses are precision drafting tools used for drawing circles with diameters ranging from ½ inch to 21 inches (13 to 533 mm). You can also use a compass to draw evenly spaced parallel lines. One leg has a needle point and the other holds a pencil lead or ruling or technical pen head. When drawing with a compass, remember to draw in a clockwise direction with one smooth and even motion of your fingers until you overlap your starting line.

Knives and scissors are essential tools for pasteup. The X-Acto knife (top left) takes different blades (shown on right) for cutting straight lines, curves, angles, and stencils. Some artists prefer to use a single-edged razor blade (bottom). The other knives shown here can be used for heavy-duty cutting.

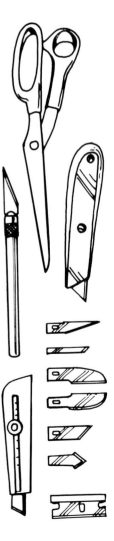

There are several different kinds of compass. A *drop bow compass* is a handy tool for drawing very small circles. A *bow compass* accommodates both pen and pencil; make sure it has an extension beam bar so that you can cover larger areas. For very large circles, use a *beam* or a *friction-lock compass.* You may also want a *clip compass,* with an adjustable clip that can hold different instruments, including knives, markers, pencils, and technical pens.

Dividers

Dividers are similar to compasses except that both legs hold needles. You transfer measurements from one surface to another by adjusting the divider to a specific length and marking that length with the needle holes.

Pasteup Tools

Tweezers are handy for picking up or repositioning small pieces of paper or type, and *burnishers* are used for rubbing down waxed or rubber-cemented type to ensure adhesion to a mechanical. Lucite *rollers,* or *brayers,* are used for a final rubdown of the entire surface of a finished mechanical, for mounting large pieces of art to boards for presentation, or for sticking spray-glued layouts together when creating a folding dummy.

A proportion wheel is handy for sizing art, as discussed on pages 62–63.

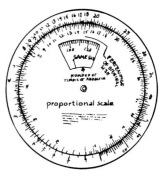

Graphic arts rules usually include at least two different measures, combining inches, millimeters, picas, or agates.

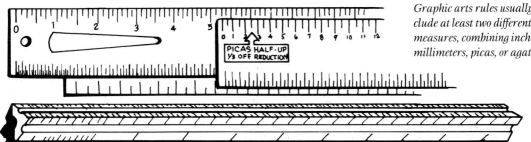

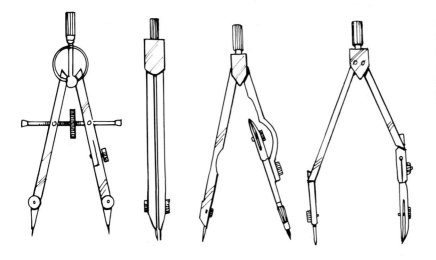

Compasses and dividers like these enable you to draw accurate circles. A bow compass (left) should have an extension bar so you can draw large circles.

PENCILS

Lead/Graphite

"Lead" pencils, made of graphite and clay, come in as many as twenty grades of hardness. Soft pencils are best used on papers that have a degree of grain, while hard leads are best on smooth surfaces. Soft leads are, from softest to hardest, 8B through B. These pencils, which are near-black in color, are good for sketching roughs and thumbnails and for covering large tonal areas. Medium leads, medium to dark gray in color, are graded HB and F. Gray-colored hard leads, which are generally used for more technical and precise work, are graded H to 10H. Hard leads are best for ruling mechanicals because they don't leave as much graphite on the surface, making the marks less visible.

Colored Pencils

Colored pencils are very useful for creating subtle tones, indicating atmospheric and light effects, and showing color gradations in color studies, roughs, comps, and general sketching. Many brands are made in a variety of grades, from soft to hard, sold individually or in sets. The soft, thick-leaded pencils can be blended for color gradations, while the hard pencils are useful for more precise work. There are also water-soluble colored pencils, which you can dissolve with water to produce color washes, or you can mix them with paint.

Other Pencils

A *mechanical pencil*, which is good for technical or mechanical drawing, consists of a plastic or metal holder containing a separate lead. No sharpening is necessary; instead, a release mechanism allows you to gradually push the lead out at the tip of the holder. Leads are available in varying degrees of hardness and different widths.

A *nonreproducing blue pencil* is an essential material in every design studio. Because this pencil's marks do not reproduce when photographed, you can use it to write and label on mechanicals.

China markers, or grease pencils, have waxy leads that are useful for labeling photographs or marking up transparencies with instructions for color correction and retouching. China marker notations are easily removed with a cloth.

Erasers

Erasers are quite specialized tools. You can use them for erasing, cleaning, or purposely smearing your art surfaces. *Kneadable erasers,* which have the consistency of soft putty, are good for light erasing without leaving crumbs. You can shape them for any area to be erased or cleaned. Soft *vinyl erasers* remove pencil marks without ghosting. Crumbly *art gum erasers* don't scratch or smudge your work surface. Firm *plastic erasers* do not smear and can be used on film. It's good to have a dusting brush handy for sweeping aside eraser crumbs and other particles.

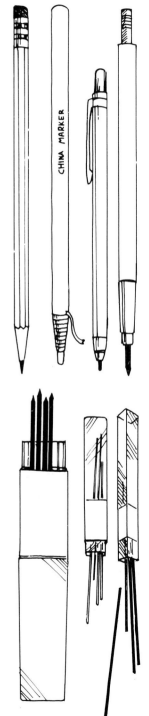

Use mechanical pencils like these to create technical drawings. Note that mechanical pencils come with leads of varying widths that allow you to draw lines of different thicknesses.

PENS AND INKS

Technical Pens

The drafting pen is an indispensable precision tool for any type of drawing, lettering, or layout work where you need a line with a consistent width. A fine metal filament (nib) is housed in a plastic sheath with its own ink cartridge that maintains a uniform flow of ink. The nibs come in as many as thirteen different sizes, creating different line widths.

Pen nibs are available in tungsten carbide, stainless steel, or jewel. Stainless steel—the least expensive—is used on paper or cloth; it is recommended for the graphic artist. Jewel and tungsten carbide nibs are good for use on film.

Technical pens must be carefully cleaned and maintained to keep them from drying up and clogging. However, pens with disposable cartridges are available, as are disposable pens.

Drawing Pens

There are pens suitable for every drawing technique from sketching and doing roughs to lettering and technical work. *Dip pens*, which include a plastic or wooden holder and interchangeable steel nibs of varying thicknesses, are especially useful for drawing, lettering, and doing roughs. Similar to dip pens, *calligraphy pens* are mainly used for lettering. They are equipped with squared-off nibs in a variety of line widths appropriate for different styles of lettering. *Felt-tip pens*, *rolling writers*, and *ballpoints* are ideal for sketching and roughs. Some manufacturers make an all-purpose pen with a cartridge-containing sheath equipped with special nibs for lettering, sketching, calligraphy, fine-line ruling, and technical drawing.

Ruling Pens

The ruling pen is a precision tool used to draw or trace sharp, solid ink, watercolor, dye, or paint lines of consistent width. They are generally used in conjunction with a supporting edge such as a T-square or triangle. You can change the width of the pen's line by adjusting the screw. One advantage of the ruling pen is that you can fill it with inks and paints of various thicknesses so that you can draw solid lines on different surfaces.

Inks

For general sketching and drawing, water- and smudge-proof artist inks are available in many colors, which can be mixed together to create more tones. There are different types of black drawing inks to suit every graphic technique. Water-soluble drawing inks are ideal for creating tonal washes.

Cartridge technical pens have compatible inks. Always confirm whether your pen requires a special kind of ink. Technical or drafting pens take nonclogging, waterproof inks made especially for use on paper, drafting film, cloth, or vellum. These come in refillable bottles. A good ink should dry quickly and stand up to pencil erasers.

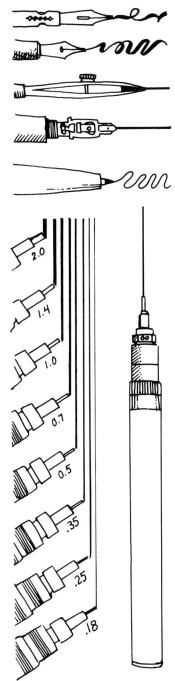

The pens shown here include (from top to bottom) a dip pen, a calligraphy pen, two different ruling pens, and a felt-tip pen. A technical pen (lower right) provides lines with consistent widths. Use nibs of different sizes to draw lines that are either thick or thin.

ADHESIVES

Wax

Many artists favor wax as an adhesive because photostats, photocopies, and type put down with wax are easy to lift off and reposition. At the same time, when burnished, the wax provides a strong bond. Excess wax can then be removed with rubber cement thinner and a tissue. Do not, however, expose the waxed material to heat. Also do not use wax on photographs or original artwork.

Desktop and hand-held waxers are available. A desktop waxer is better for regular pasteup work as it is faster and provides more even coverage. Hand-held waxers, however, can be useful for spot waxing.

Rubber Cement

Providing a more durable bond than wax, rubber cement is a staple for the mechanical artist. It is a good overall adhesive that can be used on almost any kind of art; it secures small pieces better than wax; and it is easy to control where it is applied.

One- and two-coat rubber cement are available, requiring coats on one and two surfaces respectively. Two-coat gives a more permanent bond and may be difficult to reposition when dry. Even one-coat is not as easy to reposition as wax when dry. Rubber cement can be thinned and removed with solvents; rubber cement pickup squares are also used to remove excess.

Note: Always use rubber cement in a well-ventilated area. The fumes it emits can be harmful.

Spray Adhesives

Spray adhesives are available in various tack levels, depending on the strength of the bond needed. Low-tack sprays can be used for layouts and preparatory designs, where elements may need to be repositioned. High-tack sprays are used for mounting art. Spray adhesives don't affect inks, but they do lift color from solvent-based marker drawings.

A *major* disadvantage to using spray adhesives is that they can have noxious effects if you inhale the mist. If you use them, wear a protective mask. You can also buy a plastic box in which you can spray.

Tapes

White artist's tape is a studio must. Because it leaves no residue when removed from a surface, this tape is ideal for masking or labeling artwork. It is also used for securing mechanicals to drawing boards and overlays to artwork.

Masking tape comes in varying degrees of tack. It is impervious to solvents and is good for masking or blocking out paints or sprays. Low-tack masking tape can be used to hold drawings in place and attach overlays. Lower in tack than masking tape, *drafting tape* is good for use on more fragile papers, though it will not mask solvents or paints.

Double-sided tapes are good for jobs where sprays or waxes would be too messy. Use tapes that are not rubber-based, because the latter yellow with age and become brittle. They will also stain your paper over time.

Transparent tapes, which to the camera are invisible, can be used for attaching sections of layouts together and patching artwork or type. Avoid getting fingerprints on transparent tape, because dirt and grease on your skin may leave a visible impression that will reproduce.

When two elements in a design overlap, you may need to use an overlay to distinguish them. The overlay is a sheet of transparent material on which one of the overlapping elements is positioned (the other is on the base mechanical). To ensure that the overlay and the illustration board are in perfect register, registration marks must be placed on both.

Vellum

Vellum is a heavy translucent tracing paper (see page 12) that is used for covering artwork and mechanicals. Because it is thicker than tracing paper and doesn't tear as easily, vellum is preferable for marking color breaks on mechanicals, although markers tend to smear more easily than they do on tracing paper. Vellum stretches with changes in humidity and is not best for use on art requiring exact registration.

Acetate

Made in several thicknesses, acetate is one of the most widely used overlay materials because of its stability and transparency. Heavy acetate is used to layer elements on mechanicals, while thin acetate is perfect for protecting artwork. Acetate is also used for layering elements on an illustration and for making masking stencils to protect the art surface against wet media. Specially treated acetates, such as matte, frosted, and "wet media" acetate, will accept pencil, pen and ink, paint, and water-based materials.

Mylar

Increasingly, clear Mylar is preferred as an overlay material because of its durability and stability. It is not affected by fluctuations in temperature or humidity and thus is an ideal overlay when perfect registration is required.

Masking Film

As the name implies, masking film is used primarily for masking areas you don't want exposed during photographic processes; it is also used for separations, dropouts, and reverses. *Rubylith* and *Amberlith* (colored red and amber respectively) are masking films that are impervious to ultraviolet light, so they can be used to block out areas that you do not want photographed. Both are also transparent enough for you to hand-cut detailed masks for photographs or other artwork. Amberlith is more transparent than Rubylith and is therefore preferred for detailed jobs. But Amberlith blocks out only ultraviolet light while Rubylith masks all light.

Self-Adhesive Film

A self-adhesive film may be used to protect a surface. The strong bond may be an advantage, but it also makes it hard to peel the film off without damaging the surface. Self-adhesive films come in many colors, so designers sometimes use them to indicate color fields on three-dimensional and other designs.

Frisket

Widely used as a mask by airbrush artists, frisket can also be used in liquid form to create special visual effects, such as textures and unusual shapes. You apply it with a brush, masking off an area. Later you remove the dried frisket with low-tack tape, revealing the white of the board or other surface underneath.

Use masking films to create a silhouette. Peel the excess film away after cutting the silhouette with a knife.

MARKERS

Markers are a versatile drawing tool for all stages of the advertising design process, including concept layouts, animatics, storyboards, and comps (see chapter 6). Their vivid colors can give a design layout eye-catching presence. Moreover, they dry instantly and are easy to use. You can draw with broad, sweeping strokes to fill in solid areas, create watercolor effects for a more irregular look, or draw with fine line detail.

Markers come in a wide range of colors as well as different gray tones. For even more variety and modeling effects, they can be mixed together with a blender marker or layered, building from light to dark. There are also different types of nibs. The brush and wedge nibs work well for covering large tonal areas; the flexible or medium nib is good for lettering and sketching; the fine-point nib is suited for rendering details and outlining.

Markers are either solvent-, alcohol-, or water-based. Solvent-based markers are permanent and fast-drying, while alcohol-based ones are slower to dry; both are good on illustration board, 100% rag paper, and layout paper. Water-based markers can be manipulated with water and can be used with spirit-based markers without blending; they are best used on heavier surfaces because they wrinkle paper stock. Unlike the other markers, water-based markers do not have an odor or emit potentially toxic fumes.

You can create an array of different marker strokes with specific nibs. Pictured, from top to bottom, are razor-point, flexible, wedge, brush, fine-point, and chisel-point nibs.

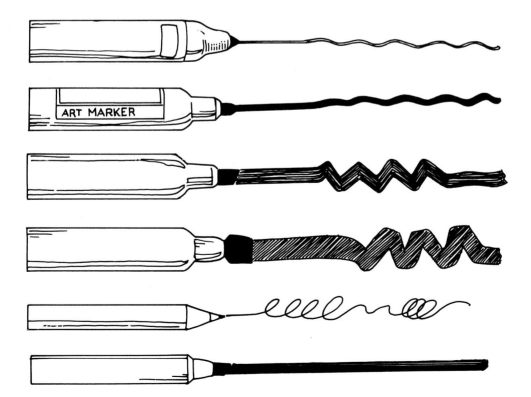

AIRBRUSHES

Once a tool used mainly by photographic retouchers and technical illustrators, airbrushes have become popular with graphic artists in every discipline. Handled well, the airbrush provides astonishing colors and textures, as well as both realistic and special effects that can surpass even the best photography for clarity.

An airbrush consists of a long needle that is attached to a nozzle chamber fed by an air source (an electric compressor or carbon dioxide cylinder), controlled with a regulator gauge. A reservoir on the airbrush holds a liquid pigment, such as dye, ink, acrylic, or gouache, which, when mixed with the compressed air, is expelled as an atomized spray.

There are important differences in airbrushes, which you must evaluate to determine the type best suited for your particular work. First, note that you can buy airbrushes designed for either left- or right-handed users. An airbrush with a *double-action* lever control is the most versatile model. It allows you to control the air-to-paint ratio and to change line value and weight without interrupting the spraying. A *single-action* model has a large nozzle that allows you to cover broad areas quickly. Though it limits fine line illustration work, it is good for large stipple patterns and textures. Another difference is that with a double-action airbrush you must keep the paint consistency thin, but with a single-action model you can spray thicker paint in undiluted color. However, with a single-action unit you can only adjust the spray pattern by altering the distance between the airbrush and the surface.

The *turbo* airbrush, the most precise model, is ideal for spraying fine, even lines for very detailed work such as minute shadows, spot highlights on metallic surfaces, and stippled textures. Unless you do large amounts of detailing, buying a turbo isn't essential; the double-action will suffice.

There are also many airbrush accessories to facilitate your work, such as holders that clamp to your desk, joint adapters that allow you to change from one airhose to another, different tips to vary the spray pattern from fine to broad, and spray traps that serve as an exhaust tube when you clean the airbrush. Other important supplies in the airbrushing studio are masking materials, such as prepared frisket film, liquid frisket, and tape, to block out the areas you don't want to spray. You will also need an airbrush cleaner and a good ventilation system.

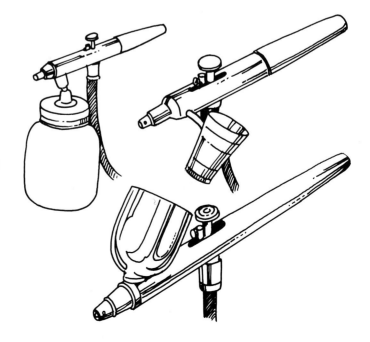

Airbrushes come in several different configurations with large or small nozzles for spraying broad areas of color or fine lines, respectively. On each of the models here you can clearly see the reservoir for the liquid pigment.

2 The Basics of Type

Good design combines many elements, and typography is one of the most important. At a basic level, type converts written copy into printed text. At a more advanced level, typography becomes an art form with the power to communicate ideas and evoke emotion.

Many designers and art directors dread specifying type—*speccing*, for short—because it seems difficult and time-consuming. However, once you have learned the fundamental principles, and if you know basic math, you'll be equipped to face almost any speccing problem. Dealing with type should be a creative challenge, not an avoided hassle.

To visually communicate the copy's content, you must first consider the intended message, target audience, and market. Then, to attract the viewer's interest with your use of type, you must balance aesthetics and mechanics. For, while type must fit within a given format, it must also speak its own language. As you select various type sizes and weights, you give type a specific voice. Type can be loud, soft, subtle, bold, light, or heavy. It has texture, color, mood, mass, and rhythm. The beauty of typography lies in its flexibility.

TYPESETTING PROCESSES

It was only in the 1960s that "cold" type, or photocomposition, began to replace "hot," or metal, type. Now computerized typesetting has changed the face of the communications field. The old methods are still available, but they are disappearing.

Metal Type

Hand-set metal type dates back to the fifteenth century. In this method the typesetter places individual pieces of engraved metal containing letters and figures into a composing stick and arranges the type one slug at a time. Though it has been all but replaced by mechanized typesetting, hand setting is still used for artistic, handcrafted pieces.

Machine-set type involves casting type from molten metal. Invented in the late nineteenth century, machine setting was widely used until the 1960s. The major systems were the Linotype, Intertype, Ludlow, and Monotype. The first three cast type in single lines, while Monotype cast it letter by letter.

Photomechanical Type

The first wave of cold type was photomechanical typesetting, whereby light was projected through a film negative of the character onto photosensitive film or paper, which could be used directly for printing or developed into reproduction-quality type for pasteup. A computer was used to process the material as it was input on the keyboard—instructing the photosetting equipment on specifications and providing rules for hyphenation.

Not only did this method require less training to use, but it was faster and more flexible than metal type. In general, it was also easier to adjust the spacing between individual letters or lines of type.

Digital Type

Today, digital, or electronic, type predominates. The main difference from earlier kinds of phototypesetting is that, instead of the typefaces being stored on film, they are stored as digital information in the computer's memory. This system allows you to generate type directly from a personal computer (if it is hooked up to an appropriate printer), or you can send a disk prepared on a word processor to a typehouse for output, without having to pay for "type*setting*" (the actual keyboarding of the manuscript). The quality of the final type varies, however, depending on the type of printer used (see page 132).

For digital type, it is important to understand the basics of specifying type explained in this chapter, even though some of the processes—for example, copyfitting or runarounds—are greatly simplified when you are working directly on a computer. The special advantages, as well as the pitfalls, of digital type are discussed in detail in chapter 8.

With digital type, the letterform may be either bit-mapped—that is, formed pixel by pixel—as shown on the left, or outlined from key points that describe the character's shape.

TYPE TERMINOLOGY

Before you begin to specify type, you need to know the language of type.

A *character* is any single type letter, figure, or punctuation mark. Capital letters are referred to as *uppercase* characters, or *caps*, and small letters are *lowercase*. *Ascenders* are the upper strokes of certain lowercase letters (such as b, d, or h) and *descenders* are the downward strokes (as in g, j, or y). The *x-height* is the height of a lowercase "x," or the body of a lowercase letter (not including its ascenders or descenders).

A *typeface* is a particular design of an alphabet. Typefaces may be broadly classified as either *serif* (characterized by "tails" that trail off the strokes of the letters) or *sans serif* (without serifs). An entire alphabet (including numbers, fractions, punctuation marks, and symbols) of one style of characters is called a *font*; it can include up to nearly 500 characters. A type *family* consists of all styles of a particular typeface, its various weights and postures. A type's weight is specified from light to heavy (including book, bold, ultra, condensed, and expanded types), while its posture is either vertical (*roman*) or slanted (*italic*).

Type sizes are measured in *points*. There are approximately 72 points to an inch. In general, the size of a type is the number of points from the top of the ascender to the bottom of the descender, but there are exceptions. The length of a type line—the *measure* of the copy—is described in *picas*. A pica contains 12 points. There are approximately 6 picas to an inch (25 mm). Type is always specified in points and picas, not in inches or millimeters.

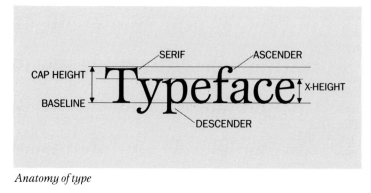

Anatomy of type

Futura Light
Futura Light Oblique
Futura Regular
Futura Regular Oblique
Futura Bold
Futura Bold Oblique
Futura Extra Bold
Futura Extra Bold Oblique
Futura Light Condensed
Futura Light Condensed Oblique
Futura Regular Condensed
Futura Regular Condensed Oblique
Futura Bold Condensed
Futura Bold Condensed Oblique
Futura Extra Bold Condensed
Futura Extra Bold Condensed Oblique

Different type weights and postures

SELECTING TYPE

Thousands of typefaces have been created over the years, and selecting a typeface can seem a challenging task to the beginning designer. But as you work with type more and more, you will build a personal library with a few tried-and-true styles. Some common typefaces are Times Roman, Century, Garamond, Optima, Helvetica, and Futura. The families of these faces contain such variations as light, medium, demi, bold, italic, condensed, and expanded.

When choosing a typeface, you must consider its legibility and its "personality." The right typeface can elevate a good design to an extraordinary design. The selected typeface affects how text copy fits within a design and how well it reads. Another factor to consider is how economical the typeface is in terms of space: some faces will fit more words onto a line than others.

Every designer should have type specimen books for selecting type. Spec books provide samples of different typefaces (including capitals, lowercase letters, numbers, and punctuation marks) and usually include a chart indicating the average number of characters per pica or per line length for different type sizes. Knowing this figure is necessary for copyfitting (see page 36). If your type house does not have a spec book for their selection of typefaces, you may need to get a type sample set.

When choosing a typeface, you must consider its legibility and its "personality." The right typeface can elevate a good design to an extraordinary design. The selected typeface affects how text copy fits within a design and how well it reads. Another factor to consider is how economical the typeface is in terms of space: some faces will fit more words onto a line than others.

When choosing a typeface, you must consider its legibility and its "personality." The right typeface can elevate a good design to an extraordinary design. The selected typeface affects how text copy fits within a design and how well it reads. Another factor to consider is how economical the typeface is in terms of space: some faces will fit more words onto a line than others.

When choosing a typeface, you must consider its legibility and its "personality." The right typeface can elevate a good design to an extraordinary design. The selected typeface affects how text copy fits within a design and how well it reads. Another factor to consider is how economical the typeface is in terms of space: some faces will fit more words onto a line than others.

When choosing a typeface, you must consider its legibility and its "personality." The right typeface can elevate a good design to an extraordinary design. The selected typeface affects how text copy fits within a design and how well it reads. Another factor to consider is how economical the typeface is in terms of space: some faces will fit more words onto a line than others.

The same copy set in the same size can look very different, depending on the typeface you choose. Here the examples are all 9-point type; the faces, from top to bottom, are Adobe Garamond, Lubalin Graph Book, Bodoni, and Frutiger 55.

LINE SPACING

In today's typesetting, the space between lines of type is called *line spacing*, although it is often referred to as *leading* (a term that describes the actual lead inserts placed between lines of type in metal type composition). Line space is measured from the baseline of one line of type to the baseline of the next. It is this space that determines how many lines will fit within a particular column depth.

Unless you instruct the typesetter otherwise, type will be set *solid*, with no extra space between the lines. To specify this, you would write 9/9 Caslon (referred to as "nine on nine"). Thus, 9-point Caslon would be set with 9 points between baselines. For text type, one-point leading—one point more than the type size—is commonly specified. In our example, this would be 9/10 Caslon. In general, longer lines need more spacing between them, and faces with large x-heights need more spacing than those with small x-heights.

In phototypesetting the space inserted between lines of type is called *line spacing*, although it is often referred to as *leading*. Line spacing is measured from the baseline of one line of type to the baseline of the next. It is this space that determines how many lines will fit within a particular column depth.

In phototypesetting the space inserted between lines of type is called *line spacing*, although it is often referred to as *leading*. Line spacing is measured from the baseline of one line of type to the baseline of the next. It is this space that determines how many lines will fit within a particular column depth.

In phototypesetting the space inserted between lines of type is called *line spacing*, although it is often referred to as *leading*. Line spacing is measured from the baseline of one line of type to the baseline of the next. It is this space that determines how many lines will fit within a particular column depth.

In phototypesetting the space inserted between lines of type is called *line spacing*, although it is often referred to as *leading*. Line spacing is measured from the baseline of one line of type to the baseline of the next. It is this space that determines how many lines will fit within a particular column depth.

In phototypesetting the space inserted between lines of type is called *line spacing*, although it is often referred to as *leading*. Line spacing is measured from the baseline of one line of type to the baseline of the next. It is this space that determines how many lines will fit within a particular column depth.

The same text is set here in 9-point Caslon but with different line spacing. From top to bottom, the line spacing is solid (9/9), 1 point (9/10), 2 points (9/11), 3 points (9/12), and 4 points (9/13).

With headlines, which are usually set in display type (type 18 points or larger), you may want very tight line spacing. It is possible to specify *minus leading*, where there is less space than with type set solid—for example, 40-point type on 38, or 40/38. With minus leading, the ascenders move closer to the descenders in the line above. Be careful not to condense so much space between lines that the descenders of one line touch the ascenders of the next and the copy becomes difficult to read. Most often, minus leading is used when the copy is all caps.

In contrast, with text type you may want to open up the leading to give an airier feeling to the piece. For instance, 12-point type might be specified 12/16. If you are setting a relatively small type on a wide measure—for example, 8-point type by 26 picas—a more open spacing (8/11 or 8/12) can make the copy easier to read from one line to the next.

Line Spacing
in Typography

Line Spacing
in Typography

Line Spacing
in Typography

LINE SPACING
IN TYPOGRAPHY

LINE SPACING
IN TYPOGRAPHY

LINE SPACING
IN TYPOGRAPHY

With lowercase letters, minus leading may cause the descenders of one line to touch the ascenders of the next, as in the first example of 20/18 Caslon. This problem does not occur with 20/19 Caslon (middle) or 20/20 Caslon (bottom). Minus leading can be effective for headlines in all caps. The last three examples here are 20/18 Caslon, 20/19 Caslon, and 20/20 Caslon (top to bottom).

LETTER AND WORD SPACING

Letterspacing is the amount of space between individual characters. You can specify letterspacing to be as tight or as open as you like, as long as it remains legible. Some letter combinations appear to have more space between them than others, and you may want to bring them closer together through a process called *kerning*. Although kerning removes space between characters, the letters *appear* to be consistently spaced with other letters in the word. (You can also add space if letters appear too close together.) Kerning should not be confused with a *ligature* (two letters joined together to form a unit).

The spacing between words is referred to as *word spacing*. Normal spacing between words allows your eye to flow along a line of type and down a page. If spacing is too wide or too narrow, the copy may become difficult to read. Word spacing is also affected by the type style you choose. Condensed faces need less space than expanded faces do.

Letterspacing is the amount of space between individual characters. You can specify letterspacing to be as tight or as open as you like, as long as it remains legible.

Letterspacing is the amount of space between individual characters. You can specify letterspacing to be as tight or as open as you like, as long as it remains legible.

Letterspacing is the amount of space between individual characters. You can specify letterspacing to be as tight or as open as you like, as long as it remains legible.

Letterspacing is the amount of space between individual characters. You can specify letterspacing to be as tight or as open as you like, as long as it remains legible.

The four examples are all set in 9/11 Times Roman. However, the letterspacing varies from very tight (top), through tight and normal, to loose (bottom). Take any single word—specify, for example—and compare it in the four examples.

Studio Techniques

Studio Techniques

The same 24-point Times Roman headline is shown without kerning (top) and then kerned.

AT AV TA Ta Te To Tr WA Wa we VA YA Ya Yo

These are letter pairs that usually require kerning.

Sometimes you may want a set amount of spacing between certain words (for example, between a run-in head and the text), or you may need to indicate space for paragraph indents. This kind of space may be specified in *em* or *en* spaces. An em is the square of a type's point size. For example, if the type is 10 points, then the em space is 10 points wide × 10 points high. An en is half the point size width. In a 10-point typeface, an en would be 5 points wide × 10 points high. The type size thus determines the em or en spacing.

To specify the spacing between words in general text, you can request tight, very tight, normal, or loose spacing. Traditionally, typesetters refer to letter and word spacing in terms of ems and ens, although it is measured in units on phototype equipment. For example, "3-to-em" is one-third the size of an em. A 12-point typeface that is specified 3-to-the-em will have 4 points of space between words.

The spacing between words is referred to as *word spacing*. Normal spacing between words allows your eye to flow along a line of type and down a page. If spacing is too wide or too narrow, the copy may become difficult to read.

The spacing between words is referred to as *word spacing*. Normal spacing between words allows your eye to flow along a line of type and down a page. If spacing is too wide or too narrow, the copy may become difficult to read.

The spacing between words is referred to as *word spacing*. Normal spacing between words allows your eye to flow along a line of type and down a page. If spacing is too wide or too narrow, the copy may become difficult to read.

The spacing between words is referred to as *word spacing*. Normal spacing between words allows your eye to flow along a line of type and down a page. If spacing is too wide or too narrow, the copy may become difficult to read.

The spacing between words is referred to as word spacing. Normal spacing between words allows your eye to flow along a line of type and down a page. If spacing is too wide or too narrow, the copy may become difficult to read.

The first three examples here are all set in 9/11 Times Roman, but the word spacing varies from tight (top) through normal to loose. When there is too little space, words may run together. With too much space, the white spaces in between jump out at the reader.

The last two examples are set in 9/11 Helvetica Condensed and 9/11 Helvetica Expanded (bottom). Condensed type needs less word spacing, and expanded needs more.

TYPE ALIGNMENT

There are different ways to specify the arrangement of type in a column depending on how you want the copy to read. *Flush* describes type that is aligned evenly with the left or right margin, and *ragged*, or *rag*, describes type that is not evenly aligned.

When you specify *justified* type, the entire column of copy will be squared, with the type flush left and flush right. Justified type, however, can produce uneven letter- or word spacing, especially if you use relatively large type on a narrow measure (for example, 11-point type × 9 picas). The problem is accentuated if you tell the typesetter you don't want hyphenation. Even if you allow hyphenation, it can be difficult for the typesetter to maintain a consistent number of characters in the column.

Many designers prefer to set type *flush left/ragged right* (FL/RR) because the word spacing is consistent and, at the end of each line, your eye returns naturally to the even left margin. With ragged type, it is advisable to specify not only a maximum width, but also a minimum, to avoid a very uneven rag. However, if you specify no hyphenation, it may be impossible to avoid an uneven rag.

There are other type arrangements for special design situations. *Flush right/ragged left* (FR/RL) is often used for captions placed on the left of an illustration. With *centered* type, each line is set centered on the specified measure. You might use centered type for a headline, a short formal announcement, or an invitation. You can also spec each line individually— as might be necessary with some kinds of poetry.

Justified with no hyphenation ×9

When you specify justified type, the entire copy column will be squared, with the type flush left and flush right. Justified type, however, can produce uneven spacing between words, especially if you use a relatively large type on a narrow measure. The problem is accentuated if you tell the typesetter you don't want hyphenation. Thus many designers prefer to set type flush left/ragged right.

Justified with hyphenation ×9

When you specify justified type, the entire copy column will be squared, with the type flush left and flush right. Justified type, however, can produce uneven spacing between words, especially if you use a relatively large type on a narrow measure. The problem is accentuated if you tell the typesetter you don't want hyphenation. Thus many designers prefer to set type flush left/ragged right.

Ragged right with no hyphenation ×9

When you specify justified type, the entire copy column will be squared, with the type flush left and flush right. Justified type, however, can produce uneven spacing between words, especially if you use a relatively large type on a narrow measure. The problem is accentuated if you tell the typesetter you don't want hyphenation. Thus many designers prefer to set type flush left/ragged right.

Ragged right with hyphenation ×9

When you specify justified type, the entire copy column will be squared, with the type flush left and flush right. Justified type, however, can produce uneven spacing between words, especially if you use a relatively large type on a narrow measure. The problem is accentuated if you tell the typesetter you don't want hyphenation. Thus many designers prefer to set type flush left/ragged right.

The examples on these pages show spacing problems you may encounter with justified copy, where letterspacing or word spacing may be added to a line so that the copy will flush right. With ragged-right copy, the letterspacing and word spacing are always even throughout the copy. However, not allowing the typesetter to hyphenate can result in an uneven rag, as in the example set by 12.5. With copy that is ragged left, watch out for a short last line, as in the example on page 31.

Justified with no hyphenation × 12.5

When you specify justified type, the entire copy column will be squared, with the type flush left and flush right. Justified type, however, can produce uneven spacing between words, especially if you use a relatively large type on a narrow measure. The problem is accentuated if you don't want hyphenation.

Justified with hyphenation × 12.5

When you specify justified type, the entire copy column will be squared, with the type flush left and flush right. Justified type, however, can produce uneven spacing between words, especially if you use a relatively large type on a narrow measure. The problem is accentuated if you don't want hyphenation.

Ragged right with no hyphenation × 12.5

When you specify justified type, the entire copy column will be squared, with the type flush left and flush right. Justified type, however, can produce uneven spacing between words, especially if you use a relatively large type on a narrow measure. The problem is accentuated if you don't want hyphenation.

Ragged right with hyphenation × 12.5

When you specify justified type, the entire copy column will be squared, with the type flush left and flush right. Justified type, however, can produce uneven spacing between words, especially if you use a relatively large type on a narrow measure. The problem is accentuated if you don't want hyphenation.

Justified with no hyphenation × 22.5

When you specify justified type, the entire copy column will be squared, with the type flush left and flush right. Justified type, however, can produce uneven spacing between words, especially if you use a relatively large type on a narrow measure. The problem is accentuated if you tell the typesetter you don't want hyphenation.

Justified with hyphenation × 22.5

When you specify justified type, the entire copy column will be squared, with the type flush left and flush right. Justified type, however, can produce uneven spacing between words, especially if you use a relatively large type on a narrow measure. The problem is accentuated if you tell the typesetter you don't want hyphenation.

Ragged right with no hyphenation × 22.5

When you specify justified type, the entire copy column will be squared, with the type flush left and flush right. Justified type, however, can produce uneven spacing between words, especially if you use a relatively large type on a narrow measure. The problem is accentuated if you tell the typesetter you don't want hyphenation.

Ragged right with hyphenation × 22.5

When you specify justified type, the entire copy column will be squared, with the type flush left and flush right. Justified type, however, can produce uneven spacing between words, especially if you use a relatively large type on a narrow measure. The problem is accentuated if you tell the typesetter you don't want hyphenation.

Ragged left with hyphenation × 12.5

Flush right/ragged left is often used for a caption to the left of the illustration, but is difficult to read for longer texts.

Centered × 12.5

With centered type,
each line is set centered
on the specified measure.
You might use centered type
for a headline,
a short announcement,
or an invitation.

In a type layout, how the body copy is broken up by paragraphs or heads affects its readability and visual impact. There are many creative ways to arrange these elements.

Paragraphs

It is standard to indicate a paragraph by either indenting the first line or adding space before the next paragraph. Many designers also do not indent the first line of the first paragraph or the first line of the paragraph following a head.

A typical paragraph indent is between 1 and 3 ems. But depending on the column width and arrangement of type, these specs can vary greatly. Unconventional indents, such as a *hanging indent,* can add drama to a paragraph. In contrast to a regular indent, the first line of text in a hanging indent is set full measure and all the lines following are indented.

Heads, Subheads, and Lead-ins

In addition to paragraphs, you can use various levels of heads to clarify the organization of the text or emphasize important points. A *headline* is considered the most important line of type in a design because it must catch readers' attention and entice them to read further. A *subhead*, or secondary head, visually breaks up long text passages and helps to identify salient information within the copy. There are many different ways of making subheads stand out from the text. Usually they are set on a separate line, in a different style from the text (for example, bold or italic if the text is roman, or in sans serif if the text is a serif face).

One way to indicate a paragraph is with the text flush left and an extra line space in between paragraphs.

This style gives you clear blocks of text, providing distinct pauses between paragraphs.

Another way to indicate a paragraph is by indenting the first line. A typical indent is 1 em, especially if the type measure is relatively short.

For type set on a relatively wide pica measure, a 2-em or even a 3-em indent may be preferred. A large indent may also be used for emphasis.

A hanging indent can add drama to a paragraph. Here the first line is set full measure and all the lines following are indented.

These examples of different paragraph styles are all set in 9/11 ITC Clearface. The sample copy describes the style used.

HEADLINE

Subhead

LEAD-IN. This is followed by text.

The first line is 20-point Kabel bold; the second, 12-point Kabel bold; the third, 9-point Bembo.

Headline

Subhead

Lead-in followed by text.

The first line is 22-point Bembo bold; the second, 14-point Bembo bold italic; the third, 9-point Bembo bold and roman.

Lead-ins set off the first words or sentence of a paragraph in a different style—most often in bold or italics. They can serve as a lower-order subhead or as a means of emphasizing certain points.

Extracts and Runarounds

Excerpted material, such as a long quote, is usually set as an *extract:* in smaller type or a different posture within a more narrow column width than the body text. There is usually extra space above and below an extract to further set it off.

One popular device for adding visual interest to text design is a *runaround*—type that is set to wrap around other type or illustrative elements. Though you can design runaround text in many ways, the formula for speccing the type is the same. Begin by tracing the shapes of both the illustration or type and the text on a tissue, leaving a consistent pica space between the edges of the two elements. Next, draw in the baselines for each line of type. At the edge of the longest line, draw a vertical line and continue all the horizontal baselines to meet it. Following the contour of the runaround shape, indicate the end of each baseline with a short vertical rule if the runaround is on the right and the beginning of each if it is on the left. Finally, measure the pica length of each line of text, and give the typesetter both the drawing and the manuscript.

A quick method for typesetting runarounds is to simply send the tissue tracing to the typesetter. Include specifications for typeface, size, and leading with instructions to "set to fit." Computer typesetting (see chapter 8) is even easier: the computer automatically runs the copy around the indicated area. You can then adjust the word spacing, hyphenation, or point size as needed.

This runaround is set in 9/11 Bembo with the width narrowing in accord with the image.

Runarounds are set to wrap around an illustration or another type element. A simple runaround might follow the outline of a figure, an animal, or an object. At first it may be easier to work with a slightly irregular contour, as this allows for more variation in the line lengths. Avoid paragraph breaks within a runaround, as the change in spacing may be confusing.

Although display type is generally described as type 18 points or larger, any highly noticeable type can fall within this category. One purpose of display type is to communicate quickly, cuing the reader to the content of the text to follow. At the same time it can play a major part in the aesthetics of a design. Display type is used for headlines, initial capitals, or as art in itself.

In addition to the normal text faces, designers can choose from a variety of gothic, ornamental, and script faces for display type. Display type can also be handwritten or created by an artist; it can combine different typefaces within the same sentence; or it can be type that has been mechanically or photographically altered for a desired effect.

Because of its size and prominent position in the design, you need to take special care in specifying display type. Pay particular attention to the letter- and line spacing. With a headline set in all caps, for example, you may wish to use minus leading, as discussed on page 26. The position of ascenders and descenders in lowercase type can also affect spacing, as may a large initial cap.

To determine how display type will appear in a final layout, it helps to create a rough comprehensive by tracing from sample type (see page 105). Or you can use photocopied samples. Always consider the readability of display type layouts. You can easily catch the viewer's eye with an unusual presentation, but you don't want to lose the viewer's attention with illegible type.

Transfer Lettering

You can buy type on sheets that can be manually transferred to a layout, or you can have regular headlines and type galleys produced in rubdown form by your typesetter (see the discussion on page 90). Transfer lettering comes as either a self-adhesive cutout that you stick down or a pressure-sensitive letterform that you burnish onto the work surface. Many designers use transfer lettering to indicate display type on preliminary designs and for simple type layouts. Transfer lettering is rather expensive and unwieldy for extensive layouts, but it does offer a selection of unusual faces that may be perfect for a logo, an initial cap, or a short line of type.

Any type used for text type can also used for display type. In addition, there are many faces that command attention in headlines, although they would be difficult to read at length in body copy—as can be seen from some of the examples here.

Avant Garde

Benguiat Book

Cooper Black

COPPERPLATE GOTHIC

Eurostile Bold

𝕱𝖊𝖙𝖙𝖊 𝕱𝖗𝖆𝖐𝖙𝖚𝖗

Hobo

Reporter No. 2

STENCIL

UMBRA

SPECIAL TYPE FORMS

To set off text, enumerate items in a list, or add visual pizzazz to a page, the designer can turn to a number of devices. An *initial cap* is a large uppercase letter set into the copy to signify the beginning of the text or to add a decorative visual element to a column. *Raised initials* rise above the top of the text, while *drop caps* align with it. It is important to leave extra space around a cap to ensure visibility. To specify spacing above a cap, for example, you might tell the typesetter to "leave 2 lines space above."

Another popular device is a vertical or horizontal *rule,* which can be used purely for graphic effect or to emphasize particular phrases or words. A *hairline* rule is the thinnest (¼ point wide). You can also specify rules from ½ point to 72 points in width. Indicate the rule's length in picas.

For a decorative effect, you might choose a *scotch rule,* which consists of two or more parallel rules of varying point sizes. For *borders,* you can select anything from typeset graphic details to artist-rendered decorative motifs. Often rules and borders are printed in a second color.

Bullets are often used for items in a list. They can be either round or square, open or solid, and are specified from 1 through 72 points. *Dingbats* are small ornamental designs, such as a pointing finger or a pair of scissors. They can be used for emphasis or simply as a decorative touch. Most type houses have their own catalog of special ornaments.

Finally, there are *pi characters,* special characters not usually included in a font. Examples include accented letters, mathematical and astronomical signs, and special ligatures.

An initial cap can rise above the text.

An initial cap can drop into the text, aligning with the second or third line of type—or whatever you specify.

An initial cap can be given a decorative treatment. You might, for example, use letters from an old hand-drawn alphabet.

The text here is set in 9/11 Optima. The raised initial in the first example is 18-point Optima; the drop-cap in the second example is 30-point Optima; and the raised initial in the third example is a decorative outline face.

To the left are ½-point, 1-point, 2-point, 4-point, and 6-point rules; below are a variety of dingbats.

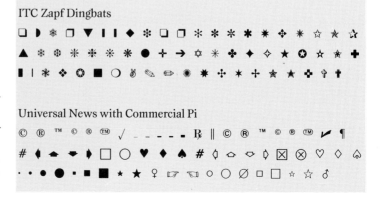

ITC Zapf Dingbats

Universal News with Commercial Pi

When specifying a typeface, size, and measure for the typographer, one of your main goals is to fit the type within the layout. Beginning with a typewritten manuscript and a rough layout, you can estimate the amount of space the total number of characters will fill when typeset—a process called *copyfitting*.

The methods described here are traditional copyfitting methods. Please note that when you design with a desktop computer, you can use programs that will automatically count characters. For less involved typesetting jobs, simply arrange the copy directly on your computer screen as it will appear in the final design and then adjust it as needed (see chapter 8).

Character Counting

Your first step in copyfitting is to calculate the total number of typed characters in a manuscript, including individual letters, figures, punctuation marks, and spaces between words. If the text was prepared on a typewriter, be aware that typewriters may vary in type size and the spacing between characters. *Elite* typewriters have 12 characters per inch, while *pica* typewriters have 10. Copy with 25 lines of elite typewriting with a 5-inch average line length will have 1500 characters (5 inches × 12 characters per inch × 25 lines).

Today it is more common for copy to be prepared on a word processor or even a desktop system. If the copy is prepared unjustified, counting characters is both easier and more accurate than with justified copy, where the spacing between characters varies. With unjustified copy, you simply select an average line and count the characters. With justified copy, however, you must count the characters in a few typical lines and divide the total by the number of lines to reach an average. It's a good idea to average high; your count is likely to be off a few percentage points, and it's better to have more space than too much copy.

Counting a Manuscript

To determine the total number of characters in a full page of manuscript, place a ruler along the right edge of an average-length line. Lightly draw a vertical pencil rule at this point; then count the characters to the left of the rule.

Multiply the number of characters per average line by the total number of lines in your copy or, for a long manuscript, the first page. Add to this total the number of extra characters to the right of the vertical line; then subtract the number of empty spaces to the left of the line. Remember to count 1 space at the end of a line if there is a word space before the next line, 2 spaces at the end of a sentence (if that is how the manuscript is typed), and 2 spaces for an average paragraph indent. Do not count spaces at the end of a paragraph.

Once you've counted the first page of a long manuscript, you can estimate the rest of the pages, provided they're the same length.

The copy on the facing page has 45 characters to the left of the vertical line. To count all the characters, you add any characters to the right of the line (including a character for a word space at the end of a line), and you subtract any blank spaces to the left of the line. Multiplying 45 by 15 lines and then adding and subtracting characters as indicated, you arrive at the total number of characters in this piece of copy.

I'm/leaving/my job/soon/and my/boss/couldn't/be/happier

Okay, the truth is I _am_ the boss, and have been

for two years.

I'm a young art director with a successful

Connecticut shop--where I handle everything from

account management to paper clip inventory. And I've

had enough.

So I'm giving myself a pink slip. Because I've

discovered how limiting my unlimited job description

can be.

But before I terminate my employment, I'd like

to discuss employment with you, and the job of creating

great advertising--which is the job I do best.

If you'd like to talk, you can reach me at (123)

123-1234 or (123) 321-4321.

If you'd like a reference, just talk to my boss.

-5 8

-31

-5 3

45 4

15 -1 9

225

450 -6

675 8

77 8

752 -38

118 -5 7

$-$ 10

634 2

-5 9

-17

9

-5

634 # -118 77

COPY CASTING

Copy casting, or casting off, involves fitting the counted copy within your layout. First determine the pica width (or measure) of the type block to be set.

Next determine how many characters of a particular typeface fit into this measure. Let's say you've chosen 9-point Caslon type. In your type specimen book, look up how many characters of 9-point Caslon will fit into 1 pica. Then multiply this number by the measure to see how many typeset characters you will have per line. If you don't have a type table, use a specimen of the typeface and size you've selected, mark off the line length, and count the number of type characters that fit the measure.

If, for example, the set character count is 50 characters per line, then divide the total manuscript character count by 50 to determine the number of lines of type (1500 characters divided by 50 set characters = 30 set lines). Now that you know the number of set lines, you have to make sure they fit the specific column depth. To do this, you first need to decide how much space to leave between lines.

With our example, let's say we are setting 9-point Caslon with 2-point leading, or 9/11. If there are 30 set lines, then they will take up 30 × 11, or 330 points (27½ picas) of space. An easy way to determine the copy depth is to use a Haberule, which measures the line spaces for different leadings from 6 to 15 points. If your copy doesn't fit, there are several options: you can select a larger or smaller point size, alter the leading, adjust the layout, or expand or shorten the copy by rewriting and deleting material.

I'm leaving my job soon and my boss couldn't be happier.

The manuscript on page 37 is shown here in the layout. In this case the average number of characters per typeset line (approximately 45) is almost the same as in the manuscript, so that you might do your copy casting by eye. Only in the fourth paragraph of type do you gain a line from the manuscript.

Okay, the truth is I *am* the boss, and have been for two years.

I'm a young art director with a successful Connecticut shop — where I handle everything from account management to paper clip inventory. And I've had enough.

So I'm giving myself a pink slip. Because I've discovered how limiting my unlimited job description can be.

But before I terminate my employment, I'd like to discuss employment with you, and the job of creating great advertising — which is the job I do best.

If you'd like to talk, you can reach me at (203) 966-5907 or (203) 854-9424.

If you'd like a reference, just talk to my boss.

After a manuscript has been copy-edited and the design has been approved, the next step is to mark it up, indicating the specifications for the typesetter. Manuscripts should be typed double-spaced on 8½ × 11-inch paper. For clarity, it's best to use a pencil or pen that is a different color from other markings on the manuscript. And it's very important that your specifications be written as clearly as possible, because misread instructions can result in wrongly set type. Never assume that the typesetter will know how to fill in missing specifications.

The information you need to provide to the typesetter includes typeface and weight, point sizes, line spacing, line length, flush or ragged, upper and/or lowercase, indents (if any), and letter- and word spacing. For a lengthy manuscript, it is best to prepare a spec sheet for the typesetter, encompassing all the different elements, such as text type, heads and subheads, captions, and extracts.

(FL)

After a manuscript has been copyedited and the design has been approved, the next step is to mark it up, indicating the specifications for the typesetter. For clarity, it's best to use a pencil or pen that is a different color from other markings on the manuscript.

The information you need to provide to the typesetter includes typeface, weight, point size, line spacing, line length, flush or ragged, and so on.

TEXT: 9.5/11.5 Esprit Book × 12.5 pica FL/RR

TYPE SPECIFICATIONS FOR STUDIO TECHNIQUES
Chap. No.: 1³⁄₁₆-inch-high Franklin Gothic Bold Outline
Chap. Title: ⅜-inch-high Franklin Gothic No. 2 u/lc, FL × 26 pica
Chap. Intro. Text: 12/15 Esprit Book × 26 FL/RR; initial cap 24 pt. Franklin Gothic FL on baseline of first line of text; paragraphs indent 1½ ems.
Text: 9.5/11.5 Esprit Book × 12.5 FL/RR; lead paragraph following head FL; other paragraphs indent 1 em.
A Head: Set at top of page; 14/14 Franklin Gothic No. 2 caps × 36 FL; center between two rules 27 pts. apart. Top rule: ½ pt. rule × 36. Bottom rule: 2½ pt. rule × 36. Leave 30 pts. b/b bottom rule to text below.
B Head: 10/11.5 Franklin Gothic No. 2 u/lc × 12.5 FL. One line space above; text FL below.
Captions: 9/11 Esprit Italic × 9 FL/RR (or as marked), no paragraph indent on first line.
Folio: 10 pt. Franklin Gothic No. 2, flush outside, drop 2 picas from last line.

TYPE PROOFS

When your job is set, the typesetter will return the original manuscript and *galley proofs* of the typeset copy for proofreading and design checks (including checking the fit of the type). Indicate any typesetting errors on the galleys with appropriate proofreading marks and designate if these are PEs (printer's errors) or AAs (author's alterations). PEs must be corrected at the typesetter's cost, while AAs are paid for by the customer. You may also opt to change specifications once you see the typeset version of your manuscript, but this is billed as an AA.

At this point you can create a *dummy* of the layout by using cut-up galleys and photocopies of any art or photographs in the design. Editorial changes to the copy may be made in order to eliminate a "widow," a short line at the top of a column or a partial word at the end of a paragraph. You can also add lines to even up text columns and fill spaces. If any major adjustments are necessary to the design or copy, this is when you should make them.

After all changes have been indicated on the galleys, you return them to the typesetter. You can either ask for second galleys to make one more proofreading pass, or for reproduction proofs, called *repro* (final type proofs pulled on a special coated paper or high-quality photographic paper). It is the repro that is pasted down on the actual mechanical. Always check repro against the repro galley proof for any additional errors. Should you have minor changes once the camera-ready mechanicals are pasted down, you can make spot corrections with patch repro rather than replace a large area, provided that the typesetter carefully matches the density of the original type.

3 Reproduction Methods

When you prepare a design for reproduction, you face a variety of technical choices, including how to handle different kinds of artwork, whether to use special photographic processes, how many colors to use, and which printing methods to choose. A printed piece can be in black and white or color, line or tone, varnished with a glossy or matte finish. The possibilities are endless.

When visualizing a design, you should keep in mind from the beginning how all of its components will be reproduced. Reproduction is a translation process, so the final piece will never look exactly like the original art. Every reproduction method has its limitations. It is important to be aware of what will happen with different methods to transform your ideas into a final piece that meets your and your client's highest standards.

In choosing a reproduction method, you determine not only the final appearance of the printed piece, but also its cost. Often a client will have budget restrictions, so you must know how to get the most out of different methods.

LINE ART

Line art is any solid black art without tonal gradations in the overall image or the line itself. Line art can consist of any combination of lines, rules, dots, or solid marks. While a solid black ink stroke is classified as line art, a pencil drawing containing varying degrees of gray is not.

Line art can be made with a graphite pencil (provided the strokes are solid), a grease or charcoal pencil, a pen, or a brush with ink or paint. You can also create *reverse* line art, where the lines appear white against a black ground. You can reverse the art photographically (the same can be done with type), or you can scratch white lines into a flat black field of paint.

Although line art does not contain any grays, it is possible to create an illusion of tone by grouping black lines or dots in different amounts in the original art. A pen and ink drawing is a good example. It is also possible to shoot line art through a screen to create different tints (see page 50). Also keep in mind that although the original line art is prepared in black (or sometimes in red, which photographs as black), a printer can reproduce it in any ink color that you choose.

This contour line drawing consists of solid black ink lines.

Here the illusion of tone within the ink drawing is created with a series of dots and carefully spaced parallel lines.

With a reverse line art drawing, white lines appear against a black background.

CONTINUOUS-TONE ART

Any image that contains a range of tonal values from white to black is called *continuous-tone art.* For example, a photograph, unlike line art, is composed of an infinite number of gray tones. Anything from dye, watercolor, tempera, and oil paint to pencil, chalk, and pastel can be used to make continuous-tone art. In graphic design, however, the photograph is the most common type of continuous-tone art.

Because a printing press prints only solid color—black ink, for example—continuous-tone art must be converted into line art. The image is scanned or photographed through a screen that breaks up the tones into a series of tiny dot or line patterns that suggest tone. The darkness or lightness of an area depends on the size of the dots and their closeness to each other. The larger and denser the dots, the blacker the area appears. The resulting image, composed of many tiny dots, is called a *halftone*.

Halftone Screens

The special screen through which continuous-tone art is photographed is called a *halftone screen*. It consists of a grid of fine lines that break up the image into a series of dots, of varying size, when light passes through the screen and exposes the negative or film paper.

The number of lines per inch to a screen (the screen *count*) can vary, making the dots coarser or finer. A 150-line screen has 150 lines per inch, creating 22,500 dots per square inch. With more lines (and dots) per inch, the dots become smaller, making for finer gradations of tones. With 133 lines to the inch and higher, the dot pattern becomes indiscernible to the naked eye. The printed halftone then appears more like the original.

When choosing a line screen, you should consider the quality of the paper to be used. Certain rough and inexpensive paper stocks, such as newsprint, are highly absorbent, causing the ink to spread. This spreading decreases the amount of white space between the printed dots and darkens the image. In this case, a

In the enlargement of this halftone you can clearly see the dots.

coarser screen—65 or 85 lines—may work best. In fact, a 65-line screen is typical for newspaper printing. On smoother papers, where less ink is absorbed and the dots retain their shapes, a finer screen, such as 133 or 150 lines, is better. You should also take the brightness of the paper into account—the more reflective a paper is, the brighter the whites will be.

Finally, be aware that printing presses have specific capabilities, and that the higher the line screen you are using, the more precise the printing press must be.

Laser Scanning

More and more, laser scanners are being used to reproduce black-and-white halftones. Rather than photograph through a screen, the laser scanner reads the continuous-tone copy with a high-beam laser. The computer-controlled laser subdivides darks, lights, and midtones into a range of gray levels, which translate into various dot patterns.

In addition, the computer can be programmed for a range of special adjustments. It can adjust the dots up or down in specific gray areas without changing the balance of other areas. The scanner can also select degrees of image sharpness, from regular to increased (heightening the light/dark contrast) to decreased (softening the halftone). Because of the scanner's greater resolution and flexibility, a laser-scanned halftone tends to be superior in quality to one photographed by a standard copy camera. At the same time, the greater resolution means the scanner picks up any flaws in retouching.

65-line screen

85-line screen

100-line screen

120-line screen

133-line screen

The choice of halftone screen affects the quality of the reproduction. With more lines, there is usually finer detail, but you must also consider the paper the image will be printed on.

TYPES OF HALFTONES

Square Halftone
A common way to reproduce contin-
uous-tone copy is with a square half-
tone. The image is "squared off,"
with right-angle corners, forming a
square or a rectangle. Halftone dots
cover the whole surface. You can also
ask for an oval or round halftone, but
the square halftone is most common.

Silhouette or Outline Halftone
It is possible to remove the back-
ground behind an image to highlight
the image or eliminate unnecessary
details. To make a silhouette, or
outline halftone, the halftone dots
around the image are removed, so
the image appears on a white back-
ground. To reduce printing costs,
you may want to create a silhouette
directly by cutting a Rubylith or
Amberlith mask (see chapter 1).
With new developments in printing
technology, however, some printers
(or separators) can make the silhou-
ettes mechanically, getting much
more precise results at relatively
little extra cost.

Dropout or Highlight Halftone
The dropout technique is often used
to achieve strong highlights within a
halftone image. The screened dots in
the areas to be highlighted are elimi-
nated or "dropped out," leaving only
the white of the paper on printing.
This technique can be used to avoid
a toned background when you are
reproducing a drawing done on
white paper.

Square halftone

Silhouette

Dropout

Combination Line/Halftone

A combination shot includes both line and halftone. In order to maintain the special qualities of each, the line and continuous-tone copy are photographed separately—the line as line art so that the black is full-strength and the continuous-tone copy as halftone. The two are then combined for reproduction. In a combination shot, the line can be surprinted (printed over the halftone) or dropped out of the halftone.

Ghosted Halftone

In a ghosted halftone the image is much lighter than a normal halftone. Usually you specify the darkest tones—for example, "make darkest darks 40% black." You may want a ghosted halftone as background for type, or you may want to use it instead of a silhouette, making the background fainter than the main image area. In the latter case, a mask is used to block out the background area, which is ghosted by special photographic exposure techniques. The predominant image is in clear detail and appears to pop out of the background.

Combination shot

Ghosted halftone

VELOXES

To save on printing costs, it is possible to prepare a mechanical entirely as line, as long as you can convert any continuous-tone art into a velox. Like a halftone, a velox is made by photographing continuous-tone copy through a screen, converting it into a pattern of dots. The difference is that a velox is printed as a positive photographic paper print, while a halftone is a film negative that the printer must strip into the page. In general, velox screens are not as fine as halftone screens, so quality is not as good. A tight screen is 100 or 120; looser screens are 55, 65, or 85. The lower the number, the larger the dots are.

When you paste the velox directly on the mechanical board along with all of the other line copy, everything can be photographed together in one shot. There are no additional stripping costs as there are with halftones. Another advantage of using a velox is that you can work directly on its surface with white or black opaque paint, should you want to add highlights or solid areas.

A *composite* velox is a print in which all halftones, line art, and copy have been composed into a single piece. Composite veloxes are provided to publications for reproduction and in some cases are accompanied by the film negative.

This image was printed as a velox. Four different screens were used. From left to right, they are 55-line, 85-line, 100-line, and 120-line.

SPECIAL EFFECTS

By converting continuous-tone copy to line copy through a customized line screen, you can create any number of special effects, dramatically transforming the mood and visual impact of a particular image. Among the line patterns to choose from are vertical, straight, wavy, and circular lines; crosshatching; or a wood-grain, pebblelike, steel-etched, mezzotint, or woven effect.

With a line conversion, the result is usually of high contrast. The reproduced image acquires a graphic appearance, but lacks certain details. Blacks and whites predominate over subtle gray tones.

Many advertising designers use line conversions when the reproduction of halftones would not be feasible or cost effective, or simply for aesthetic reasons.

Posterizations

With the posterization process, tonal areas are separated from the black-and-white areas of continuous-tone copy using a high-contrast line negative. But rather than make one line shot of the original continuous-tone, four shots are made with various degrees of under- and overexposure. These shots are then reassembled into a single image. The final image retains much of the original detail, but its tonal areas are distinct, enhancing its graphic impact.

These images show various special effects. At the top right is the original halftone; on the top left a wavy line screen was used. The middle images use a mezzotint screen (left) and a cross-line screen (right). On the bottom is one type of posterization.

49

FLAT COLOR

Flat color, also referred to as *match color*, is a particular hue that the designer tells the printer to use or match. A job can be done in one color (1/C), two colors (2/C), three colors (3C), four colors (4C), or more.

If you print something in one color, it is printed in only one color. Black counts as a color. It is possible, however, to use tones of a color (see below) for different effects.

With two colors, you have many more choices. You can, for example, mix the two together in various proportions to achieve a variety of tones and even a third color (blue and yellow create green, for instance). When choosing two colors, designers often combine black and a second color to enhance the halftones and text type. Which second color you choose, however, depends a lot on your design. Different colors have different limitations. If, for example, you plan to use the second color for type, it is best to avoid a very bright hue, which may be too dazzling to read. For photographs of people, you will probably want a warm, reddish or orangish hue rather than a cool blue or green.

While printing with three colors can add even more range to a printed piece, production is nearly as or as expensive as using four-color process, which is the superior method for achieving full-color reproductions (see page 54).

Flat Tones

Any flat color you choose can be screened to a percentage of its full-strength value and reproduced as a flat tone, or *tint* of color. In a flat tone the dots are all of equal size and equally spaced, so there are *no* gradations of tone. This is different from a halftone screen, where the dots are arranged to show the varying values of gray within an image.

The value of the printed tone depends on the number and size of the dots within the tint. Smaller dots create lighter tones because there is more white area between them; the reverse is true for larger dots. The designer designates tints by indicating the percentage of solid black or solid color—for example, 10%, 20%, or 100% black (the latter being solid black). You can use a tint as a background color and print a halftone, line art, or type over it (surprinting). It is also possible to drop type or line art out of a tint. If you surprint type, make sure there is enough contrast with the background for the type to be legible. You may not be able to read dark blue type on a dark gray (almost black) background. Similarly, if type drops out to white from a very light tint, it will not be distinct enough to read.

Color Matching System

The PANTONE® MATCHING SYSTEM was developed in the 1960s to help designers and printers speak the same language when dealing with color choices. Though today there are other color-matching systems available, the PANTONE system is used by printers around the world.

The original system, based on eight PANTONE Basic Colors, PANTONE Black, and PANTONE Transparent White contained some five hundred colors. Recently, PANTONE added more than two hundred colors to the original palette, creating what is now called the PANTONE MATCHING SYSTEM 747XR. This new system includes

	0%	10%	20%	30%	40%	50%	60%	70%	80%	90%	100%

COLOR

The range of flat tones

an additional PANTONE Basic Color, Violet, and a variety of new tones.

All of the colors are numbered and available in a PANTONE Color Specifier swatchbook; the swatches can be detached and placed with artwork to indicate to the printer the color you desire. The designer usually specifies the PANTONE color on the actual mechanical for the printer to match. Color swatches are arranged according to a "U" or a "C" designation, showing you how the color will appear when printed on either an uncoated or a coated paper stock. It is important to remember that PANTONE ink swatches are printed on white stock. If you are not printing on white paper, your actual printed color may vary from what you and your client expected. To ensure the proper results when printing on a paper darker than white, choose a slightly lighter ink. Always communicate closely with the printer, who can color-control the ink to your specifications.

Also, a line of PANTONE colored markers, self-adhesive overlays, and printed papers is available so you can do presentations, comps, and layouts in the same color that you've specified for printing. These products help you control the color throughout a job as well as show the client approximate colors intended for the printed piece.

Duotones

To create deeper, richer images from halftone reproduction, you can use black and another tone or color. In a duotone two halftones of the same black-and-white photographic image are printed one over the other. Although a black-and-white halftone can be printed on top of a color background, the effect is flat compared with a duotone, where the color is incorporated in the halftone itself.

With a duotone, typically one plate is made from film shot to bring out the image's highlight areas, while the other plate is shot for the shadow or dark tones. The two halftone screens are angled differently so that the dots don't overlap when printed and create a distracting moiré pattern.

Duotones can be printed in any colors; you can also vary the percentage of the colors to obtain different effects. You might, for example, print one duotone in 100% black and 95% color and another duotone in 100% black and 50% color. Depending on the colors or tints you select, you can enhance or even shift the mood of the original artwork.

Another possibility is to print black for both colors to get what is termed a *double-black duotone*, a very rich black-and-white image that reflects the deep blacks and contrasts of a glossy photograph. Keep in mind, however, that the double use of black counts as a second color.

The halftone below is shown printed over a flat tone of color (on the top of page 53) and as a duotone in 100% black and 100% color (on the bottom of page 53).

When reproducing full-color continuous-tone copy, the original artwork is "separated" into four colors, which are then combined to achieve the effect of full color in the final reproduction. This type of printing is referred to as the *four-color process*. With the four-color process, the original color art is broken down photographically or electronically into four specific *process* colors—magenta (red), cyan (blue), yellow, and black. The separation process creates four separate pieces of film (one for each color), which are developed and printed on individual printing plates. When the plates are printed together, the resulting image gives the illusion of full color. (*Note*: It is important to differentiate four-color-*process* printing from four-color printing in which four flat tints are used.)

If you look at a full-color reproduction with a magnifying glass, you will see that it is made up of dots of the four process colors. These dots mix optically—much as the dots in a pointillist painting by Georges Seurat mix in your eye. For example, where you see a green, there will be dots of cyan, yellow, and perhaps black in a particular proportion, determined by the particular shade of green. Though there are limitations, almost any color can be reproduced by combining different amounts of the four process colors. Special color charts show you how the process colors combine.

There are, however, colors that cannot be matched exactly with process color. For example, if you plan to reproduce a photograph by the four-color process for an advertisement, and you also have a logo that is a flat color, you can give the printer a PANTONE swatch to follow for the logo color, but the match will be an approximation. If the company logo must match an exact PANTONE color or colors, the printer may have to add a fifth or even sixth flat color to the four process colors—increasing the cost of the job.

Photographic Separation System

Traditionally color separations have been made photographically. With this system, the full-color copy is photographed with filters to produce four separation negatives, each representing the specific density of one of the four process colors. Each separation is also shot at a different angle through a screen so that the image appears as a pattern of dots.

Electronic Scanning

Today most color separation is done with electronic scanners because of their superior quality and higher reproduction speeds. Before scanning begins, an operator takes readings and inputs the proper settings and variables into the scanner controls for color and contrast qualities and enhancements, sizing and scaling, screen ruling (desired dots per inch), and so on. The original artwork (which must be flexible) is then mounted on a rotating drum and exposed to a high-intensity light or laser beam. The scanner's built-in computer converts the signals picked up by this beam into four screened separation films, one for each of the four process colors.

Color-correcting methods can be built into the computer system, eliminating much manual correcting. The scanner can combine multiple expo-

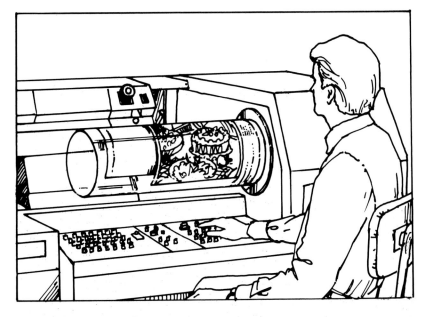

Electronic scanner

sures of many elements such as type, graphs, charts, drawings, tints, and multiple separations on the same film. Another important innovation allows the color-separated image to be stored in digital form.

There are several considerations to make when choosing between electronic or photographic separations, such as cost, quality, size, surfaces, and subject matter. Both photographic and electronic methods produce high-quality separations, but when an original is substituted with a transparency, electronic scanning is the better and less expensive method. There are, however, limitations for art to be reproduced on a scanner. The original art must be flexible to be mounted on the drum, and it cannot be too large. Only a few large, expensive scanners will accept copy larger than 20 × 28 inches (51 × 71 cm), and only up to sizes of 38 × 48 inches (97 × 102 cm). Oversize art must be separated photographically or converted to a transparency for the scanner.

PRINTING PROCESSES

When all of the artwork and copy has been photographed and the film developed, printing *plates* are made from either the film negatives or positives. Whatever the printing method, the plates differentiate the areas to be printed from those that will not print.

Letterpress

The oldest printing process is letterpress, also called *relief printing*. The surface to be printed is raised above the background; it is inked by rollers and pressed onto the paper to make an image. The surrounding low areas don't print.

Letterpress plates are made by bringing a film negative into contact with a metal plate that has been given a light-sensitive coating. Light passes through the negative and hits the plate; these exposed areas act as resists—when the plate is immersed in acid, they stand up to the acid, while the rest of the plate is etched down to a predetermined depth. The result is a raised image area, which can be easily inked. First, however, the plate is *blocked*—mounted on a wood or metal surface to make it high enough for the press.

Traditionally, letterpress plates are made of zinc (used for line and coarse screen work), magnesium (for finer details), or copper (for high-quality linework). For long runs, however, duplicate plates may be made of plastic, sometimes with a metal coating.

Gravure

In gravure, a form of intaglio printing, the image to be printed is etched into the plate's surface. In other words, the areas to be printed are lowered (as opposed to the raised areas on letterpress plates). As with an etching or engraving, the entire plate surface is inked and then wiped clean with a "doctor blade" so that ink remains only in the etched areas. When the plate is run through a press, the ink is forced out of the incised areas and onto the paper.

With gravure, all the copy, both tone and line, is broken up into dots, or cells. The intensity of lights and darks depends on the depth and diameter of the etched areas; the deeper the cell, the more ink it holds, thereby leaving more ink on the paper. While gravure printing provides rich blacks and excellent halftone reproductions, it is not as good for reproducing delicate typefaces because the whole image area is screened.

Gravure presses are either *sheet-fed* (printing individual sheets of paper) or *web-fed* (printing onto a roll of paper). Gravure printing offers high-speed black-and-white or color printing with consistent quality, which is very economical for long press runs. Gravure is most likely to be used for newspaper magazines, mail-order catalogs, color inserts for newspapers, and packaging.

Offset Lithography

Because of its flexibility and relatively low cost, offset lithography is the most popular printing process today, used for nearly all processes, including advertising, magazines, books, catalogs, packaging, posters, newspapers, and greeting cards. It is appropriate for both long and short press runs with either sheet- or web-fed presses.

Lithography uses the planographic

With letterpress printing, the image is raised up on the surface of the plate.

With gravure, the image is etched into the plate.

With offset lithography, the image lies on the surface. It is treated chemically to distinguish it from the background.

method of printing, where the printing surface is flat rather than raised. The printer treats the image area with chemicals so that it accepts ink and rejects water. The areas not to be printed are treated to accept water and reject ink. Then, on the press, the plate is mounted on a cylinder, and both water and ink are applied to the plate's surface.

The inked image on the printing plate is then "offset" (printed) onto a rubber blanket that is wrapped around a rotating cylinder. The image is then transferred onto the paper from the blanket. An advantage to printing on the rubber blanket is that its malleable surface transfers a clearer impression to many different textures of paper, as well as other rough or smooth surfaces (including metal).

Screen Printing

In traditional silkscreen printing, the ink is forced by a rubber squeegee through porous silk (stretched over a frame) onto a flat surface. The silk contains a stenciled image, produced either manually or photographically. The stencil blocks the ink from passing through the silk to the non-image areas. The final printed image is distinguished by its thick film of ink.

Today, screen printing technology has been improved through the development of automatic presses and fast-drying inks. Rotary screen presses allow even speedier production.

Because stencils are inexpensive to produce, screen printing is more economical for short print runs than other printing processes. But because the ink is thick, fine detail is more difficult to reproduce. In general, screen printing is a versatile process; any flat surface can be used, from heavy paperboards or fine paper to wood, glass, metal, plastic, and fabric. For specialty, small-run jobs, screen printing can provide distinctive artistic ink textures for special mailings, comps, brochures, posters, and packages. The screen process is ideal for printing oversized displays, billboards, decals, and the like.

Flexography

This process, which is related to letterpress, uses rubber or photopolymer printing plates, usually on a web-fed press. As with letterpress, the image area to be printed is raised.

Flexography is widely used for packaging as it is possible to print on plastics, metallic films, foils, corrugated surfaces, cellophane, Mylar, and the like. It is also used for direct mail and inserts. In addition, it has found widespread use in the newspaper printing industry, partially because letterpresses can be converted to flexo presses.

Besides its ability to print on almost anything, the advantages to flexography are found in finer screen resolutions, denser inks that cover areas well, and high-quality four-color registration. The disadvantages are that the inks tend to dry too quickly, and the plates often fill up and cause a loss of fine detail.

With screen printing, a stencil is used to create the image.

CHECKING COLOR PROOFS

Before running a job, the printer should show you proofs of the piece so that you can check the color, the sizing of and placement of artwork, and the overall quality of reproduction. *Prepress proofs* are made from screened separations before the final plates are made. There are also proofs—called *press proofs*—that are made on a press (often a small press). If you go on press to check a job, you will see *press sheets* (made on the actual press, during the press run, using the actual ink and paper).

The four basic types of prepress proof systems used today are the electronic, the overlay, the integral, and the digital. Some of the common proofs available are bluelines or brownlines (paper proofs for checking type and layout), Color Key and Chromacheck (both overlay proofs for checking if color is in the correct position), Cromalin, Matchprint, Signature, and SpectraProof (all ways of judging color and registration).

Each proofing system has its own advantages and disadvantages. Bluelines or brownlines, for example, are inexpensive, but they reproduce everything in a blue or brown tint, so you cannot check color. On a straightforward two-color job, however, different exposure times can be used for each color, creating a tonal variation and thus allowing you to check the color breaks. Color Key and Chromacheck proofs, which are somewhat more expensive, do show color breaks, but not the actual color. Cromalins and Matchprints, which are still more expensive, are produced in full color, but they use powders or a lamination system rather than actual inks. Press proofs, however, do use inks.

Whatever proofing system you use, be sure to check everything carefully. Once you go on press, it becomes quite costly to make corrections. When checking proofs, evaluate the sharpness of the images and the accuracy of the colors or tones by comparing the originals with the proofs. Check the registration, or alignment, of the films (if an image is out of register, you'll be able to see dots of color straying beyond the edge). Also make sure the image is correctly positioned on the page and that it isn't "flopped" (reversed left to right) or printed upside down. Look for blemishes, spots, or scratches in the dot structure, and check for broken or missing type. If there are type or other areas that print in flat color, make sure that the color breaks are correct. Examine neutral areas (whites, grays, blacks) to make sure they don't have a green or blue cast. Finally, check that the folios (page numbers) are correct.

Four-color-process proofs should include a color bar, showing the four process colors, against which the density of colors can be checked with a densitometer. In addition to the four process colors, the bars may include tints, overprints, star targets (indicating that the press is printing properly and not blurring), and gray balance scales. To adjust a color, you can ask the printer to decrease the yellow ($Y-$) or increase the cyan ($C+$), whatever is needed. You can also indicate adjustments in contrast and detail. Mostly, however, it is best to leave the necessary adjustments up to the printer. If you think that an image is too red, mark that, but allow the printer to determine the proper color adjustments.

Mark proofs for:
1. *Broken type or rule*
2. *Missing type or image*
3. *More/less contrast*
4. *Uneven tint*
5. *Incorrect color break*
6. *Flopped image*
7. *Upside-down image*
8. *Out-of-focus image*
9. *Dirt or scratches*
10. *Too much/too little yellow, magenta, or cyan*

SPECIAL FINISHES

Embossing and Debossing

Embossing creates an actual raised area on the front surface of the paper. This process can be done in conjunction with a printed area, producing a relief image in register with the printed image. Or it can be done as a *blind embossing,* where an image or type is raised on the blank paper, without the use of ink.

With debossing, the opposite effect is obtained: the specified areas are recessed. Embossing and debossing are often used to give a high-quality look to letterheads, business cards, and invitations.

Stamping

Stamping is technique used most frequently to create a debossed effect on book covers. Because dies are used, this process is sometimes referred to as *die stamping.* Most often, pigmented or metallic foils are used, giving a matte, glossy, or iridescent finish. It is also possible to do a *blind stamping,* without using foil, leaving just the recessed impression of the image or type.

Thermography

Thermography, like embossing, produces a raised image. The image is first printed conventionally using a special adhesive ink. A thermoplastic resin is added to the printed image, and then heat is used to fuse the powder with the printed ink, making the area hard, raised, and glossy. Thermography is much less expensive than processes using dies, but it cannot reproduce fine detail.

Varnishing

For an attractive, glossy or matte finish over an entire printed piece, or select portions of the piece, the printer can apply a varnish during or following printing. Frequently, a varnish is used to protect a piece that may be handled often. But a varnish has many more design uses. To get the most out of halftones on a matte or dull coated paper, you can apply a glossy varnish to them. Conversely, on a gloss coated stock, you can use a dull varnish to decrease the glare in the text area. Spot varnishing can be used to give sheen to a mirror or enhance a three-dimensional illusion. Another possibility is to use a tinted varnish, instead of ink, for a clear but subtly muted effect.

Die stamping is often used for a logo or similar device on a book cover.

Protective Coatings

Besides conventional varnish, you can use a *UV-cured coating* to protect a printed piece. This special type of varnish is dried by ultraviolet radiation. It gives a piece a high gloss and excellent protection against handling.

Film laminate is a clear plastic film that is adhered to a printed surface to give both a high gloss and protection. It is most often used for textbook covers or high-quality packaging.

Another, highly durable protective coating is a *water-base* or *aqueous coating,* which is more environmentally sound than other coatings. This finish is frequently used for package designs on heavy paper or board.

Die Cutting

With the die-cutting process, steel rules positioned in a wooden die are used to cut shapes out of paper or board. This process, which provides very exact edges, is often used for packaging designs, greeting cards, and other pieces with cutout shapes.

4 Basics of Art Preparation

For top-quality reproduction, it is important that the art be prepared correctly. All too often, the difference between an excellent printed final and an unsuccessful one is a badly prepared piece of art or a miscommunication between the creative and production people.

A critical design decision you must make is how much of a photograph or illustration to use and at what size. If a photographer is hired to do a shot for an ad or another piece, the art director usually specifies the kind of photo needed—asking, for example, for a closeup or panoramic view. Sometimes the photographer even receives a sketch of what is wanted. And most illustrators receive very specific instructions on what is wanted. Still, you may want to change the size of an image or its boundaries (cropping it), as these two aspects can directly affect the ultimate impact a design has on the viewer. How you treat a photograph or an illustration can add interest and dramatic effect to a presentation, making the difference between a dull, straightforward presentation and a spectacular, award-winning design.

HANDLING ART AND OTHER COPY

Any copy, from photographs and illustrations to type, must be handled with extreme care. Never write directly on top of a photo, because the pressure of the pencil or pen can leave impressions on the surface that may be seen in the printed piece. Also avoid writing on the back of a photo with a ballpoint pen or a pencil, as the impressions may show on the other side. Instead, use a grease crayon or a soft felt-tip pen, or better yet, use a tag attached to the photo.

Never paper-clip a photo or repro without proper padding; clips can dent the photo and may scratch the type. In addition, never fold or roll a photo because you may crack the emulsion and leave creases. Avoid fingerprints on photos or transparencies; the oil from your skin may remain on the surface and show up on the printer's negative. Keep transparencies protected in a sleeve.

Evaluating Black-and-White Photographs

When choosing a photograph for reproduction, you should pay attention to the quality of the original print, as the quality of the final halftone will depend on this. Check, for example, that the image is in focus (unless, of course, your design calls for a soft, hazy blur). If the only photograph available is out-of-focus, you may be able to minimize the problem by greatly reducing its size.

Also look at the tonal values. Do the highlights have clean, crisp whites, yet still retain detail? Are there rich, fully saturated blacks, without a loss of detail in the shadows? Is everything black or white (high contrast), or is there a gradual transition, with a variety of grays?

Keep in mind that the reproduction process tends to heighten contrast. That doesn't mean, however, that you should opt for a flat, mostly gray image. In most cases you want a *range* of tones from white to black.

Finally, look for any imperfections, such as black or white dots. Any spot that's on the print will be reproduced. Fortunately, it is relatively easy to repair these imperfections, as described on page 68.

Evaluating Transparencies

As with black-and-white photographs, it is important to check the focus of a transparency. Use a magnifying glass or loupe, and check the entire image. If you are working with a 35mm slide, you will probably be enlarging it considerably—so a sharp focus is doubly important.

While you are looking through the magnifier, also search for any imperfections. A tiny pinhole, when enlarged, can be a major detraction. If you do find a scratch or similar defect, it is often best to either choose another image or reshoot.

Now check the exposure, making sure the image is neither too light (overexposed) or too dark (underexposed). Also, avoid high-contrast shots (unless you are looking for this effect). You should be able to see detail in both the shadows and the highlights. If anything, contrast will increase on press.

Finally, check the color balance. Look, for example, at the white areas. Do they have a bluish cast? It may be necessary to have an image reshot with a filter. Although you can ask the separator to do some color correcting, it is best to begin with an accurate transparency.

SCALING AND CROPPING

When dealing with a photographic image, the designer must fit its composition within the specific format of the layout. For example, if the photographer used a 35mm rectangular film frame and you want to fit that image into a square format, then the photo must be *cropped* (trimmed differently) and usually also *scaled* (sized).

Scaling artwork—figuring out the percentage of enlargement or reduction—can be accomplished a number of ways: mathematically by using a calculator, photomechanically by using a stat machine, a photocopier, or a projector, or with a Scaleograph (a tool that both scales and crops at the same time). The two most common methods of scaling are the diagonal-line method and proportional scaling.

For scaling art properly, you'll need a good ruler. Schaedler rulers are extremely accurate, offering a set of measurements for centimeters, inches, picas, agates, and points. Because they are made of clear plastic you can lay them over artwork when measuring, and they don't expand or contract with temperature changes.

Diagonal-Line Method
This method of scaling is visual and fast, although it is not always as accurate as proportional scaling. You first measure the image area you want on the layout. Next, take a piece of tracing paper and draw a square or rectangle that size, extending the baseline and left vertical lines a few inches beyond the corner. Take a straightedge and draw a diagonal line from the lower left corner to the upper right corner and beyond.

Place the tissue over the photograph and decide the width you wish to use. Mark this width on the extended baseline and draw a vertical line from that point to the diagonal line you drew before. This point represents the height needed for your original art to fit within the layout. Finish the square or rectangle by drawing a horizontal line to meet the vertical rule. Any new square or rectangle that you draw using the same diagonal line—measured from either corner—will be in exact proportion to the original.

Proportional Scaling
For proportional scaling, you can use a plastic *proportion wheel* (see page 15) to give you exact measurements for enlargements or reductions. Begin by measuring the width of the image area on the layout. Let's say it's 8 inches. Next measure the width of the original art or the area you want to use (say, 6 inches). Find 6 inches on the scale's inner wheel (marked "size of the original") and

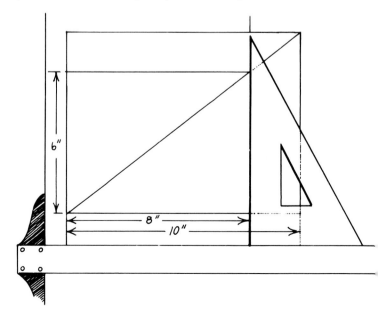

With the diagonal-line method of scaling, you can resize photographs or art to the correct proportions for the layout.

place it opposite 8 inches on the outer wheel (marked "reproduction size"). The percentage of enlargement is 133% (shown in a window on the scale). While holding the position on the wheel, measure the height of the layout space. Say it's 7 inches. This aligns with 5 ¼ on the "size of original" wheel. You may need to crop the photograph to make both dimensions correct.

You can also figure the proportions mathematically using the formula: size of reproduction/size of original = $x/100$. In our example, $8/6 = x/100$. This method is even more accurate than using a proportion wheel—especially with transparencies.

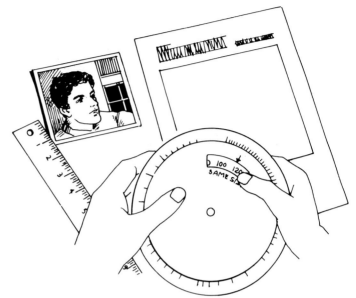

Cropping Guidelines

Although sometimes you will want to use the full photograph, often you may prefer to use only part of the image. One reason for cropping a photograph and thereby changing its shape is if the layout is set and the photos must fit the design. Other times the content of the photograph itself will determine how it is used. You may want to focus on a detail or get rid of an eyesore on one side.

First tape any unmounted photograph to your drawing board. When you have chosen the composition, frame the image area as squarely as you can and indicate the crop marks with a grease pencil in the photo's border or on a tissue overlay (see chapter 5). (After scaling the photo, you will know if the crop will work.)

When cropping photographs, it is essential to consider the mood or story that you want to relate. A badly cropped photo can detract from the message, while a well-cropped photo can effectively convey it.

You can also use a proportion wheel to calculate exact measurements for enlarging or reducing photographs or illustrations.

To show more detail in this photograph, without changing the width, it was enlarged and cropped.

PREPARING LINE ART

Whether you place line art on the mechanical to be shot directly with the type, or you have it shot separately, remember that the camera will see what your eye sees. For line art to be *camera-ready* (photographable), it must be in flawless condition and prepared on a surface free from smudges or extraneous marks. Use a kneaded eraser to remove any dirt, crop marks, or notations from the image area, making sure that you brush away any eraser crumbs. Thinner is also useful for cleaning excess cement or grease pencil marks from a photostat (see page 69). Use soft cotton pads when wiping so you don't scratch the surface.

When preparing an illustration for reproduction, always be aware of the final size of the image. Often art is prepared larger than the final size—not only because it may be easier to work on a large scale, but also because imperfections drop away and the line becomes more refined when the image is reduced.

Illustrations with thin, closely spaced, or finely crosshatched lines have to be photographed with the utmost precision to reproduce correctly. All too often the artist forgets that reducing a line will not only make it shorter, but will make it thinner as well. When reduced by camera, fine hairlines can virtually disappear, and closely spaced lines can merge together.

To troubleshoot reduction problems when preparing oversized line art, draw a few lines of different thicknesses in the medium and on the paper you are going to use. Then have them photostated at the intended reduction to see what will happen to the line. From the sam-ples, choose the best line widths for your illustration.

If you intend to enlarge an illustration, keep in mind that any imperfections will be magnified and the line will thicken and may appear uneven. Also, be aware of the scale at which you reproduce similar line items; they will contrast with each other when reproduced if you don't scale them to a uniform percentage.

Veloxes (see page 48), which are already screened, are treated as line art. When ordering veloxes, bear in mind that glossy stat paper holds a velox better than matte paper. Also, it is important to know about the paper and press to be used for the job, so that you can specify the appropriate dot screen.

Determine how lines of varying thickness will appear when enlarged or reduced before you choose the best line widths for an illustration.

Note that reducing an illustration can cause crosshatched or closely spaced lines to fill in and thin lines to disappear.

PREPARING CONTINUOUS-TONE ART

As described in chapter 3, all continuous-tone art must be screened before being printed. Mark your specifications for the photograph or art on a tag. Include a key number for identification, the size and the type of halftone desired (such as square, silhouette, or dropout), and any special instructions (such as "shoot for shadows").

On the mechanical, only the size and position of the continuous-tone art need to be indicated, as the art itself is photographed separately and later stripped into the line negative. To indicate the art's position you can simply draw a red holding line, or you can paste down a position stat or photocopy.

A red *holding line*, or *keyline*, drawn precisely around the image area indicates the exact size and position of the halftone (the red appears as a white line on the negative, into which the halftone is stripped). For easy identification, you can paste a photostat or photocopy within the holding line (see page 80). To indi-

cate that this art is not to be shot, but is "for position only," write *FPO* directly on it, preferably in red. Also, write an identification number within the holding area or on the stat that corresponds to the number on the original art.

You can also cut a stat or photocopy to the exact size of the halftone and position it on the mechanical without drawing a holding line. Be sure, however, that all four edges of the image are dark enough for the camera to record.

An older method of indicating continuous-tone art, rarely used today, requires a self-adhesive masking film such as Rubylith. First draw the holding lines in nonreproducible blue pencil, and then cut a piece of the masking film a bit larger (to cover the holding lines) and stick it where the image will be. Using a T-square, triangle, and blade, trim the masking film precisely along the holding lines. The red area photographs as a clear "window" area, indicating where the halftone is to be stripped in.

There are three main ways to use a photostat or photocopy for the position of a square halftone. You can square the stat on the board (left), place it within a red holding line (middle), or place masking film over it (right).

SILHOUETTING

When you want a photographic image reproduced as a silhouette halftone, you can mask out the areas not needed in the reproduction in your studio rather than have the printer or separator do it. By making a silhouette yourself, you will probably decrease costs. But check with your printer first. With modern technology, silhouetting is often easier and more accurate when done by the printer.

Using Opaque White Paint

Because of paint's fluidity, you can silhouette uneven contours more easily with it than by cutting a mask. There is, however, a *major* problem with using white paint: if the film is prepared with a scanner, the brushmarks may be picked up. Be sure to ask your printer about this.

If you do use paint, you will need to make the emulsion on a glossy print slightly tacky so that the paint won't roll off. To do this, wipe the area with a cotton ball dampened with saliva or thinner. Then, with a small brush, carefully trace the image's contour with a fine line. Now increase the thickness of the line to approximately ⅛ to ½ inch (3 to 13 mm). Indicate areas within the image that you want the printer to eliminate with white crosses.

To block out the rest of the background, place a sheet of tracing paper over the art and lightly trace a line in the center of the painted white border. Attach this tracing to a piece of white bond paper with rubber cement, and cut out the pencil-lined image. After removing the tissue layer, position the bond over the art. Make sure that the contours of the mask are aligned correctly and do not touch the silhouetted edge. Trim the bond paper as necessary and secure it with tape to the top of the photo.

Using Masking Film

To cut a mask for a silhouette, tape a sheet of masking film (such as Rubylith) over the art. With the dull side of the Rubylith up, carefully cut the outline of the image with a sharp knife (there are rotating blades made especially for cutting masks). Leaving the image covered by the Rubylith, peel the film away around the image, exposing the acetate underneath. The red mask covering the image guides the printer in creating the silhouette. If you make a mistake, you can retouch the mask with special masking ink that forms a film when dry.

To create a silhouette with paint, you can use a fine brush and opaque white paint to outline the image. Do not, however, use this method if the image will be scanned.

To cut a mask for a silhouette, first tape a sheet of masking film over the art and then cut an outline of the image.

Next peel the film away around the tape.

The cutout mask on the acetate overlay should be in perfect register with the image underneath.

The mask covering the image guides the printer in creating the silhouette.

REPAIRING PHOTOGRAPHS

Retouching

Computer technology is changing the entire field of retouching. Once an image has been scanned into the computer, it is possible to enlarge a small area and make minute changes (see page 131). This method, however, requires a lot of computer memory and thus is not practical for most advertising or design studios.

In general, if retouching is required—especially with color transparencies—it is best to send the images to a professional. Still, for black-and-white photographs—though major retouching should be left to a professional—it may be helpful to know how to hand-correct photographs that have blemishes, creases, or other small imperfections. If you have the negative, you can always have another print developed if you aren't satisfied.

It is best to work with as large a print as possible so that the retouched image will be reduced when reproduced. If you need more top or bottom to a photograph, or want to darken or lighten an area for type to be surprinted or dropped out, an airbrush is needed. First mount the photograph so there are no buckles or air pockets, and cover areas to be left alone with a frisket. Using broad, sweeping movements, with the airbrush 6 to 8 inches (15 to 20 cm) away from the art, gradate the tones to match the lighting. It's best to start lighter and go darker if you need to. After the retouched areas dry, cover them with acetate to avoid scratches.

To do a perfect retouching job, you must match the tones and textures within the image. All too often an overenthusiastic artist retouches a photograph until the image begins to look artificial.

Note: When a print needs tonal or contrast changes, you may not need to send it to a retoucher. If you have the negative, a photo lab can easily make adjustments in the darkroom. Any portion of a print can be isolated and darkened (burned in) or lightened (dodged). Often a new print will look better than a retouched one, and it will probably cost less and take less time.

Spotting

Spotting is a technique used to get rid of white dots on black-and-white prints. These dots result from tiny specks of dust that adhere to the film during processing. The dust blocks the transmission of light and leaves a tiny unexposed area on the photographic paper. As the negative is enlarged, so is the dot.

You can buy spotting dyes in photo stores to touch up the white areas, matching them to the surrounding tones. The dyes come with a formula sheet indicating the proportion needed to match tones on various papers. You'll also need a very fine brush, an eye dropper, water, paper tissues for blotting, and a paint tray for mixing a gray scale with the dyes. Apply the dye by stippling it, and remove any excess fluid by blotting. For prints on matte paper, you can also try using a pencil to fill in white dots, though you must fix the retouched print.

To eliminate black spots on a print, dab bleach (made of "pot ferri") with a damp brush or a cotton swab for larger areas. You can also use a sharp blade to remove black spots; try to avoid scratching the emulsion.

PHOTOSTATS

Photostats, or stats, are inexpensive photographic prints on paper made from line or continuous-tone art. A positive stat is a direct image of the original art (black on white), while a negative stat is a reversed image (white on black). A direct positive stat (DP) is produced without an intermediate negative.

Although photocopies (discussed on the next page) are less expensive, stats are still used to indicate the position of art on mechanicals (see page 80)—especially if the image's edges are not sharp, if careful cropping is required, or if the original is a transparency. A stat can enlarge or reduce the original art. (Note that if a great enlargement or reduction is made, a stat will be clearer than a photocopy.) It can also flop the art. Although inexpensive paper is used for position stats, a high-quality paper can be requested for stats to be used as the actual line art. In this case, a glossy finish is preferable because it sharpens and deepens the solid blacks, printing only in black and white, without gray tones. A matte stat, which holds some tone, is best for indicating the position of continuous-tone art, but it cannot be used for reproduction.

Color stats are available for presentation use, to give a rough idea of the color. For better quality, you may prefer a C-print (made from a film negative). Color photocopies are another option.

When ordering stats, you need to specify the size in inches or percentages. Other instructions, which can be marked in the margin of the original art, on a tissue overlay, or on a tag attached to the art, include the finish desired (glossy or matte) and whether the image should be positive, negative, and/or flopped. If you only need a section of the art in the stat, indicate this by crop marks to avoid being charged for a larger-size stat. If you have several pieces at the same percentage, they can be ganged up (shot together) to save on costs.

Negative stat (left) and positive stat flopped and reduced.

PHOTOCOPIES

Photocopy machines can not only save time and reduce costs, they can enhance the design process. Using a photocopy machine, you can reproduce four-color art or slides for presentations, enlarge and reduce art, copy onto a variety of surfaces, and much more.

Layouts and Mechanicals

Rather than order expensive photostats during the comping stages, you can use photocopies, which allow you to experiment freely with different sizes and positions within a format. You can then use these photocopies for first-stage presentation comps before design or copy changes are requested by your client. If the client wants to see a larger image, you can quickly get a new photocopy. You can even enlarge or reduce type.

If you need to get multiple approvals quickly, large document copiers can reproduce oversized originals up to 24 × 36 inches (61 × 91 cm) and can accommodate layouts, comps, drawings, storyboards, and mechanicals. These copiers can print on materials ranging from standard bond paper to vellum to card.

On mechanicals you can save money by using photocopies rather than photostats to indicate "for position only" (FPO) art. Be aware, however, that some copier machines distort the size. It is best to size the art directly and use a holding line to

Photocopies are often used for layouts, as they were for this book. The same photocopies were used as position stats on the mechanicals.

CONTINUOUS-TONE ART

Any image that contains a range of tonal values from white to black is called *continuous-tone art*. For example, a photograph, unlike line art, is composed of an infinite number of gray tones. Anything from dye, watercolor, tempera, and oil paint to pencil, chalk, and pastel can be used to make continuous-tone art. In graphic design, however, the photograph is the most common type of continuous-tone art.

Because a printing press prints only solid color—black ink, for example—continuous-tone art must be converted into line art. The image is scanned or photographed through a screen that breaks up the tones into a series of tiny dot or line patterns that suggest tone. The darkness or lightness of an area depends on the size of the dots and their closeness to each other. The larger and denser the dots, the blacker the area appears. The resulting image, composed of many tiny dots, is called a *halftone*.

Halftone Screens
The special screen through which continuous-tone art is photographed is called a *halftone screen*. It consists of a grid of fine lines that break up the image into a series of dots, of varying size, when light passes through the screen and exposes the negative or film paper.

The number of lines per inch to a screen (the screen *count*) can vary, making the dots coarser or finer. A 150-line screen has 150 lines per inch, creating 22,500 dots per square inch. With more lines (and dots) per inch, the dots become smaller, making for finer gradations of tones. With 133 lines to the inch and higher, the dot pattern becomes indiscernible to the

naked eye. The printed halftone then appears more like the original.

When choosing a line screen, you should consider the quality of the paper to be used. Certain rough and inexpensive paper stocks, such as newsprint, are highly absorbent, causing the ink to spread. This spreading decreases the amount of white space between the printed dots and darkens the image. In this case, a

In the enlargement of this halftone you can clearly see the dots.

coarser screen—65 or 85 lines—may work best. In fact, a 65-line screen is typical for newspaper printing. On smoother papers, where less ink is absorbed and the dots retain their shapes, a finer screen, such as 133 or 150 lines, is better. You should also take the brightness of the paper into account—the more reflective a paper is, the brighter the whites will be.

Finally, be aware that printing presses have specific capabilities, and that the higher the line screen you are using, the more precise the printing press must be.

65-line screen

85-line screen

Laser Scanning
More and more, laser scanners are being used to reproduce black-and-white halftones. Rather than photograph through a screen, the laser scanner reads the continuous-tone copy with a high-beam laser. The computer-controlled laser subdivides darks, lights, and midtones into a range of gray levels, which translate into various dot patterns.

In addition, the computer can be programmed for a range of special adjustments. It can adjust the dots up or down in specific gray areas without changing the balance of other areas. The scanner can also select degrees of image sharpness, from regular to increased (heightening the light/dark contrast) to decreased (softening the halftone). Because of the scanner's greater resolution and flexibility, a laser-scanned halftone tends to be superior in quality to one photographed by a standard copy camera. At the same time, the greater resolution means the scanner picks up any flaws in retouching.

100-line screen

120-line screen

133-line screen

The choice of halftone screen affects the quality of the reproduction. With more lines, there is usually finer detail, but you must also consider the paper the image will be printed on.

44

45

indicate the final size, with the photocopy as a visual guide inside.

Should you ever be caught in an emergency-delivery situation, where you can't order a photostat in time, it is possible to substitute a high-quality photocopy for line art. The copy must be solid black to ensure perfect reproduction. (*Note:* Because the paper can be torn easily, using copies on final mechanicals is not recommended as a matter-of-course.)

Special Effects

You can create interesting special effects with a photocopy machine. By adjusting the contrast buttons on the copier, you can manipulate the lights and darks within continuous-tone art. For example, to create a high-contrast image from a photograph, decrease the midrange grays in the photocopy. Manipulate the photo even more by using white paint or black ink either on the photograph or the copy.

To construct a new image from an original, make several copies of the original and then cut out and paste up different areas. For the final artwork, photocopy the entire assembly and then photostat this.

By enlarging or reducing an image, whether it be clip art, a piece of fabric, or type copy, you can create interesting textures. For example, if you don't want clean, precise edges for a type logo, make a blown-up copy of the type and then distort the edges with white or black paint. When you reduce the logo to its proper size, the image will have a ragged quality.

You can also distort type or an image by dragging the original over the photographic bar as it moves

A photograph was photocopied and then blackened for this announcement designed by Ilene Block.

Happy Birthday
Sherlock Holmes

during copying. To elongate the art, pull the copy down with the bar; to extend it, pull the copy across the bar. Also try wavy or circular motions. (*Caution*: Never look directly into the copy machine when working with the cover lifted.) To reverse (flop) type or an image on a photocopier, first copy the original on acetate, then flip it over and make another copy on your final paper.

To make a solid black silhouette from a photograph, copy the photo and then use black paint to fill in the image. You can also use the paint to retouch the edges of the silhouette. When you are satisfied with the image, make a photostat for the camera-ready presentation.

DESIGN

DESIGN

DESIGN

DESIGN

DESIGN

Moving type while it is being photocopied can create interesting distortions. (The original type is shown on top.)

Photocopies can turn a photograph into a graphic, contrasty image, as with the woman at the bottom of this design by Ilene Block.

Color Copiers

Color copiers can reproduce continuous-tone or line art through the four-color process, using yellow, magenta, cyan, and black. They have their own built-in screen, which breaks down copy into dots. These machines also have single-color capabilities, so that you can make a one-, two-, or three-color reproduction from a piece of black-and-white art. To increase or decrease the intensity of color, adjust the color balance on the machine.

Color copiers can distort, expand, and condense type to specific measurements and flop copy. Some copiers can select color from the full range of PANTONE colors. The most sophisticated copiers can produce a hue in over 600 different shades, frame or mask out specific areas, and change a color on the original image to a completely different color.

When doing a presentation, if you don't want to buy an expensive C-print, make a color copy on good-quality paper. You can also make color overlays on acetate. To achieve interesting colored or textured backgrounds, you can photocopy in black-and-white or color onto decorative colored paper by trimming the paper to fit the tray size.

The man in this design by Ilene Block was created by flopping and photo-copying a photograph and then redrawing on top—adding, for example, the hand and cane on the left.

5 Pasteup and Mechanicals

Preparing a mechanical for printing requires both skill and attention to detail. Technically, a mechanical is the stage when you place all the elements of your design—type and art—on a board with clear instructions to the printer. Yet the word *mechanical* is misleading because this final phase before printing is still a creative one. It is at this point that you must fine-tune your judgments about space and relationships between different elements in the layout.

Accuracy is critical with mechanicals. If the type is not straight or aligned with the edges, it will show in the printed piece. If the spacing between elements is uneven, this too will show. An incorrectly scaled or cropped photograph can cause difficulties and extra costs at the printing stage—as can unclear instructions or improper color breaks. Although mechanicals are often done under tight deadline pressures, it is worth it to take the time at the end to make sure everything is correctly positioned and marked and that the mechanical itself is free of dirt, pencil, or smudge marks.

ORGANIZING MATERIALS

Before you begin pasting up a mechanical, organize your materials within your work space to avoid any loss of time due to the misplacement of an essential tool. The basic components necessary to execute a mechanical, excluding the actual type and art elements are:

Illustration board
White artist's tape
X-Acto knife and single-edged razor blades
Fiskar artist's scissors
Tweezers
Drawing pencils
Technical pens
Black ink
Red, black, and nonrepro blue drawing pens or pencils
Fine-point markers
Kneaded rubber erasers
Pencil eraser
Waxer and wax
One-coat rubber cement, rubber cement thinner, pickup
Tracing paper or vellum
Heavy-gauge acetate or Mylar
Rubylith sheets
T-square or parallel bar
45-degree and 30-60 degree plastic or metal triangles
24-inch (61 cm) steel ruler with pica measurements
Transparent plastic Schaedler rule
Dividers
Register marks
Rubber cutting mat
Fine-point artist's brush
White poster or correction paint
Plastic burnisher
Lucite brayer
Push pins
Paper towels and cleanup cloth

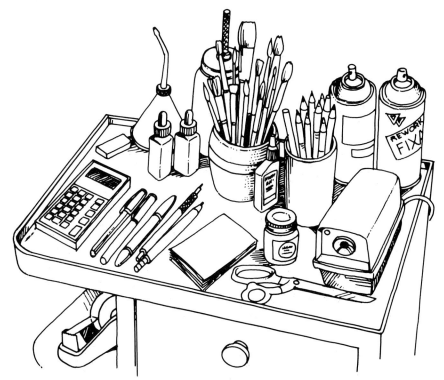

The first thing to determine, of course, is the dimensions of the piece being executed. Let's begin with a horizontal spread across two 8½ × 11-inch (22 × 28 cm) sheets of paper. Find a standard piece of illustrboard that is several inches larger on all sides than your total dimensions—in this case, 15 × 20 inches (38 × 51 cm), which is more than 11 inches (28 cm) high and 17 inches (42 cm) wide. Square it to your drawing surface with your T-square, and secure it with two 4-inch (10 cm) pieces of white artist's tape on either side.

Now find the exact center point of the board with your steel ruler. From the center measure 5½ inches (14 cm) up and the same down. Using a hard-lead pencil, such as a 5H, lightly mark a dot at these points. Also measure 8½ inches (22 cm) to the left and to the right of the center point to locate the side edges of the piece. Again, put light dots at these points.

Now connect the dots. With a T-square and a triangle, draw the outside borders using a minimum of pressure on your hard-lead pencil. Let the corners overlap and use these as guides to draw in crop marks at the four corners. Crop marks indicate the *trim*, where the printer will cut the paper. To draw in crop marks, use a fine-point technical pen with black ink. Draw these lines ⅛ inch (3 mm) away from the intersection point. Keep them a standard length—for example, ⅝ inch (16 mm). The centerline of the piece should also be delineated by broken crop marks at the top and bottom (beyond the outer margins).

When you have drawn the crop marks, you can go back and redraw

the margins, using a technical pen filled with nonreproducible blue ink. Leave the pencil marks on the board until the mechanical is completed. If you are doing a long piece, with many pages, you can ink all the margins and have the whole board printed in nonreproducible blue for as many pages as you need.

The first step in doing a mechanical is to determine the center point and the trim size of the layout.

This ruled-up board has crop marks at the edges to show the printer where to trim the final paper.

You are now ready to draw in margins, gutters, and bleeds, defining the grid of the designed piece. For example, you may decide to leave ½-inch (13 mm) margins on the outer four sides of the piece and a ⅜-inch (10 mm) gutter on either side of the centerline. On an 8½ × 11-inch (22 × 28 cm) page, you then have an area 7⅝ inches (19 cm), or 46 picas, wide for your type on each page. The measure from top to bottom is 10 inches (25 cm).

Let's say that you want three columns of type with 2 picas space in between. To determine the width of each column, subtract the total space in between the columns (4 picas) from the width of the type (46 picas) and divide the answer by 3. In this case, each column is 14 picas wide.

After you have indicated the outside type margins, lightly draw in the vertical columns in pencil, moving from left to right. At this stage it is desirable to use a transparent Schaedler rule because its measurements are more precise than those of a steel ruler.

In addition to the type areas, you should size any photos and illustrations to fit within the grid and draw them in pencil. Be sure to leave consistent spacing between the type and the images. Of course, if you have already done an accurate layout, you can simply transfer the various measurements.

Finally, you need to indicate bleed lines if you plan to run an image beyond the edge, letting it "bleed" off the paper. Draw another rectangle ⅛ inch (3 mm) outside the trim area. Any image that is to bleed must extend to this line. If the image were to end exactly at the trim line, there is a chance that the piece might be trimmed a fraction off that line, leaving a discernible white space. Bleeds are intended to compensate for inevitable fluctuations during the trimming process.

After the final grid for the mechanical has been established, type and art can be put down. Notice the double lines around the edges. The outer margin is the bleed area.

Dividers are helpful for determining equal spacing between elements.

You now have the skeleton of a mechanical and are ready to put type and art in place. Usually you will receive a photocopy of the type along with the repro. Lay the photocopy down on your layout to make sure the type fits. If it doesn't, you will need to make adjustments either in the type or the artwork to fit the space.

Once everything fits, lay the repro face down on scrap paper. You are now ready to apply wax or one-coat rubber cement to the back. Check first, however, to make sure the rubber cement flows smoothly. If not, add some rubber cement thinner.

After the rubber cement has dried thoroughly, place the repro glue-side down on a rubber cutting mat taped to your drawing board. Square the type up. Using a T-square, triangle, and a nonrepro blue pen, draw a vertical line on the left edge of the type. Let this line run at least an inch (25 mm) above and below the top and bottom of the type. Then draw a line right along the top of the type, at cap height, allowing an inch on either side. (If you are using wax, you can follow the same procedure after waxing the back of the type.)

Next trim the excess paper from the type using your T-square, triangle, and an X-Acto knife or razor blade. Leave about a ¼-inch (6 mm) margin on all four sides. By doing this, you eliminate unneeded paper and cut right across the nonrepro blue pen line you drew in. Now check that the rubber cement is dry and hand-position the type on the mechanical board using your top and side column lines as guides.

Make sure that the type is absolutely square on the board, checking

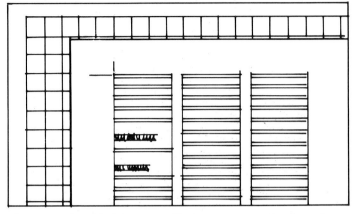

Place repro, glue-side down, on a cutting mat, square up the type, and draw nonrepro blue guidelines before trimming.

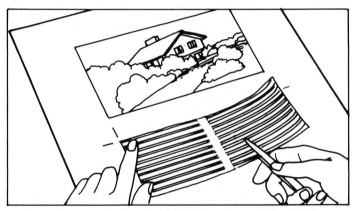

Using tweezers, transfer the repro from the cutting mat. Then hand-position the repro on the board, using column lines as guides.

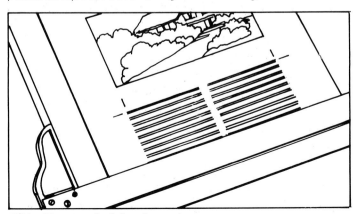

With a T-square, check that the type is square.

your hand-positioning with the T-square and triangle. If the rubber cement was dry when you put the repro down, the type should lift easily, without leaving any residue on the board. Continue to adjust the positioning until you get it right.

A common mistake is to put the copy down when the rubber cement is still slightly wet. If this happens, peel the repro up, or there will be glue bumps under the type. Clean the rubber cement off the board and the repro with a rubber cement pickup and start again. If the rubber cement was applied too thickly, the bond to the board may be too strong; it may then be necessary to slowly lift one corner of the repro off the board while squirting rubber cement thinner from a dispenser underneath.

Once all the type is in place, trim any remaining excess paper with a T-square and your X-Acto knife, and peel the strips away. This step gives your work a neat appearance. Also, by making the edges of the repro paper square with the baseline of the type, you can quickly see if your copy is square on the board. Sloppy, hand-trimmed repro on a mechanical can create the illusion that type and art are not squared.

Also, especially if you work with wax, burnish all the type using a plastic burnisher or Lucite brayer to make sure it sticks. Never use a burnisher directly on repro as you can easily damage it; always put a piece of tracing paper over the repro first.

Positioning Art

Once your type is in place, you are ready to crop and position any line or halftone art. With line art, you can follow the instructions given for

To be sure that copy is correctly centered, measure the space on each side of the type with a divider.

After the type is positioned, burnish it in place.

Use rubber cement thinner and tweezers to lift and reposition repro.

type. If the paper the art is on is fragile, you may want to use a sharp photostat rather than the original (or you can have the printer shoot the art separately). For halftone art, you will need black-and-white photostats of the original images shot at reproduction size for your mechanical (see page 65). Photocopies can be used in place of stats if time and budget are considerations, but they are not as accurate and may detract from the finish of your mechanicals when you show them to the client.

Begin by redrawing the penciled-in box described on page 77 in red ink. This box, called a *keyline* (see page 65), gives the printer the exact edges of the halftone. The color *red* tells the printer that the keyline itself is not intended to print.

Lay a piece of tracing paper over the keyline and trace it with a black technical pen, using a T-square and triangle. Then lay the tracing paper over the photostat and adjust its position until the black box frames the image as you would like to see it.

Coat the back of the photostat with rubber cement (or wax), just as you did with the type, and place it glue side down on your cutting board. Press a push pin through the corners of the tracing paper and the photostat until you feel it penetrate the rubber mat. The resulting holes need only be large enough to remain visible once you pull away the tracing paper. If you intend to crop several images to the same size, you can repeatedly use the same piece of tracing paper with the black box on it.

At this point trim only two sides of the photograph. First, align two holes horizontally and, using a T-square, make a cut from one to the next. Do the same from one vertical hole to the next. Next, taking care to remain outside the area marked by the fourth pin hole, trim away the excess paper to bring the photostat closer to its final trim size.

Lift the photostat off the mat and place its trimmed edges on the corresponding keyline edges. When you are sure that the position is correct, trim the rest of the image right on the mechanical board. If you were to cut all four sides on the cutting mat, you wouldn't achieve as accurate a fit.

If you want the image to print with a box around it, draw the box in black (instead of red) or lay down typeset repro of a box and follow the method just described. "Scallop" the edges of the photostat and indicate to the printer that the photo should butt the inside of the rule. It may, for example, be necessary to print a box around a photograph if the edges are so light that the picture loses its definition.

For a silhouetted image, you do not need a keyline. Simply trim the stat to the shape you want and place it on the mechanical. Don't forget to write *FPO* ("for position only") on this and all your position stats.

Put your photostat, glue-side down, on a cutting mat. Place a sheet of tracing paper with an outline of the image area available on top and frame the image you want. Press pins through the corners of the "frame."

The pin holes should show through on the stat and indicate where the image should be cut.

If your stat is already trimmed, mount it from the top, using a slipsheet underneath.

Trim only two sides of the image at first and position it on the mechanical.

With tracing paper on top, use a triangle edge to burnish the image in place.

When the stat is correctly positioned, trim the rest.

Clean with a tissue and rubber-cement pickup.

Many designs have art or type elements that overlap one another. In most cases the overlapping elements must be separated for the printer. To do this, you attach a sheet of acetate to the top of the mechanical. Place the sheet about an inch (25 mm) down from the top and run white tape from one end to the other. You then still have room at the top to attach a tracing-paper or vellum cover sheet later.

Surprinting

A common instance when you need an overlay is when type surprints (prints on top of) a camera-ready illustration or two different tint areas. To attach the type to the acetate, you can use wax, put a very thin coat of rubber cement on the back, or use spray adhesive (with safety precautions). With rubber cement, though, once repro is stuck to the acetate, it can be difficult to adjust. Here wax and spray adhesive are less adherent and easier to manage than rubber cement.

To gain flexibility, you may want to attach the acetate temporarily at first, using a short piece of tape on either side. Then, after you position the type by eye on the acetate, you can maneuver the acetate slightly while you square up the type with your T-square, instead of continually lifting and replacing the repro itself. Once the type is correctly positioned over the illustration, you must indicate how the acetate aligns with the base mechanical—its registration. Easy-to-use register marks are available on transparent tape. Put three of these marks on the board itself in a triangular position, outside the print area. Then put three more marks on

When one color prints on top of another, you usually must preseparate the color areas, placing one on an overlay. Make sure you include register marks on both the overlay and the base mechanical.

PANEL 40% COLOR

SURPRINTING

A common instance when you need an overlay is when type surprints (prints on top of) a camera-ready illustration or two different tint areas. To attach the type to the acetate, you can use wax, put a very thin coat of rubber cement on the back, or use spray adhesive (with safety precautions). With rubber cement, though, once repro is stuck to the acetate, it can be difficult to adjust. Here wax and spray adhesive are less adherent and easier to manage than rubber cement.

TYPE SURPRINTS BLACK

ALL TEXT TYPE BLACK

When the two color areas are discrete or easily masked out, you may not need an overlay. Ask your printer. You may be able to simply mark the mechanical as shown here for the result on the bottom.

SURPRINTING

A common instance when you need an overlay is when type surprints (prints on top of) a camera-ready illustration or two different tint areas. To attach the type to the acetate, you can use wax, put a very thin coat of rubber cement on the back, or use spray adhesive (with safety precautions). With rubber cement, though, once repro is stuck to the acetate, it can be difficult to adjust. Here wax and spray adhesive are less adherent and easier to manage than rubber cement.

the acetate so they overlay the marks on the board exactly. Registering your overlay ensures that the printer knows exactly where the overlay components print.

Because acetate is a magnet for dirt, neatness is important with overlays. It is best to have completed your base mechanical and cleaned it before you place an overlay. And, no matter how careful you are, be sure to clean the acetate with a paper towel and thinner at the end. You can also use a piece of tape to attack specks of dirt that you may have missed.

Knocking Out and Trapping

Instead of surprinting type on an illustration, you may ask the printer to "knock it out" or "drop it out" so that it prints the paper color rather than black. This is essential if you want the type to print over a dark area of the illustration. You can also ask for a second color to be printed in the knocked-out area. In both cases you need to put the type on an overlay if the illustration on the board is camera-ready. If, however, you have a position stat on the board, you may be able to paste the type directly on top—check with your printer.

Another technical possibility is to place an inset photo within a larger photo. Since you obviously don't want to print one photo on top of another, you must instruct the printer that "main photo traps to inset photo." This means that there is no separation between the two images, but they don't overlap. They literally "kiss" along the edges. For this you can use position stats and keylines directly on the mechanical—without an overlay.

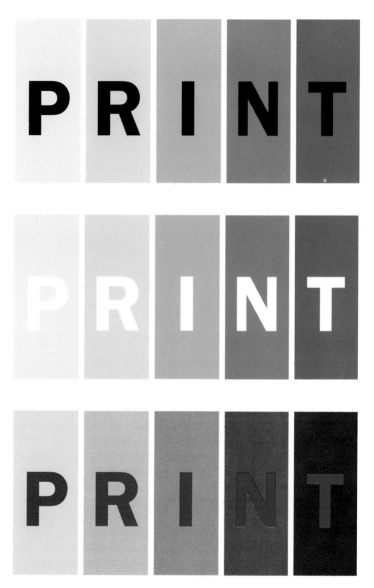

From top to bottom, you can compare the results of surprinting 100% black on tints of color, dropping out to white, and knocking out and printing color on tints of black.

After you have trimmed off the excess repro, remove any remaining rubber cement with a rubber cement pickup. (Wax is best removed with thinner on a cloth.) Wipe away eraser crumbs with a drafting brush rather than your hand, as the latter may smudge your work.

Next use an eraser to remove any pencil marks. Be very careful when you erase these pencil lines. Always be sure to erase *with* and not *against* the edges of the photostats and repro so as not to lift or wrinkle the paper.

At this stage you may find some repro edges beginning to lift off the board. If this happens, take a fine-point artist's brush and apply a small amount of rubber cement on the board under the offending corner. When the rubber cement has dried, press the area down with a burnisher until the area is attached to the board. Again, remove any excess rubber cement after burnishing.

When you have cleaned the base mechanical and any overlays, *flap* the whole assembly for protection with either a piece of tracing paper or vellum. Cover the entire board with the paper and run white artist's tape the full width to attach the paper at the top of the board. Using the edges as guides, trim off any excess tape and paper.

You are now ready to mark the mechanical for production. It is standard to use a fine-point red marker to mark a mechanical because instructions written in black or a noncontrasting color are easy to miss, blending in with the type and art. However, for color breaks (described below), it is common to use markers that roughly correspond to the colors you intend to use.

Marking Color Breaks

The first thing to do is to specify color. Let's say that the piece, an advertisement, is going to print in two colors: black and red. Select the red you want from the PANTONE Color Specifier (see page 52) and tape a color chip in the margins of the mechanical board. You might choose PANTONE Red 185. With this reference, the printer will be able to mix the color you want using a standard formula. (It is not necessary to attach a black chip to the mechanical.)

Now, suppose that you want the subheads of the advertisement to print in the red. You can either hand-trace each letter in red or simply draw red strokes through the type to indicate the color area. To keep the cover clean for presentation, you can write in the margin: "Type designated in red prints PMS 185." While the first technique gives a rough visual approximation of how the type will look in the context of the piece, it can be time-consuming to trace small letters. A third acceptable technique is to write "prints PMS Red 185" and draw a line to and around the type.

If the rest of the text prints black, you can simply write: "Type not designated prints black." Even if the text were to print in a color other than black, you can simply write: "All other type prints _____."

In addition to color breaks, you must indicate any special instructions for type—in particular, if the type is to surprint or knock out.

Marking Art

The most important words to remember when marking the photographs and illustrations on the board

are "for position only," or *FPO* (see page 65). Unless these instructions appear, a velox, photostat, or other line art will be photographed by the printer with the type, as line art. It is best to write *FPO* directly on the photostat, but you can confine the instructions to the tissue overlay to avoid defacing the image on the mechanical.

If you have a scalloped photograph within a hand-drawn or typeset box rule (not a keyline), it is important to indicate that "photo butts rules." For greater clarity, you may draw arrows horizontally and vertically to touch the inside edges of the box rule. It is

also important to indicate that the box rule prints.

A Final Touch

After marking up your mechanical, an aesthetic touch is to flap the board with kraft paper. This gives your work a professional look, although it is not needed for printing.

When shipping the mechanical to the printer, be sure to include all the original artwork, keyed to the mechanical with code letters or page numbers. One foolproof method, if size and thickness allow, is to securely tape the art in an envelope to the back of the board.

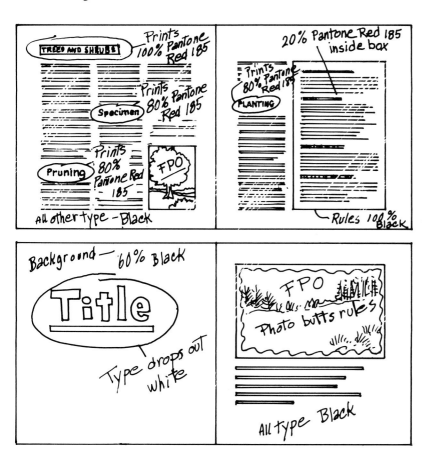

On a tissue overlay, mark color breaks on your mechanical as clearly as possible to ensure that the printer will follow your specifications to the letter.

Indicate all photostats or illustrations that are "for position only" with the letters FPO.

6 Presentations

Advertising design passes through distinct stages from initial concept to final production. At the beginning of a project, the creative team develops an idea with thumbnails and rough layouts. The agency develops tightly rendered visuals to show the client. These visual presentations are narrative tools that closely define the message and intent of the final advertisement.

The three main types of presentation are comprehensive layouts (commonly referred to as *comps*), storyboards, and animatics. Comps are used primarily to show ads in print media, while storyboards serve as visual scripts for television commercials. Animatics, a form of rough animation, can give an even closer approximation of a television commercial.

Traditionally, advertising artists have used markers to create their presentations, because this medium is easy to use and dries quickly (speed is usually critical in ad work). Today, however, many designers do their presentations on the computer, where you can quickly change the color, size, or placement of an element in the design (see chapter 8).

THUMBNAILS

As a first step in developing any project, the art director or designer executes *thumbnail* sketches (named for their small size). These thumbnails outline a variety of possible visual treatments of an idea. Artwork, headlines, and body text are indicated with cursory strokes, mainly for the benefit of the art director and the artist. It is not necessary to decide on a particular typeface at this point. These are only working sketches, presenting different possibilities for a design's basic layout and the relative scale of its elements.

In doing thumbnails, it is important to keep the overall dimensions proportional to the final ad. Later you may want to blow up a thumbnail to create a rough (see page 116). In any case, the size and shape of the ad affect the design within. If your thumbnails are done in square shapes and the final piece is a rectangle, the design you choose may not work in the final piece.

Thumbnails are working sketches, used to develop various possible treatments for a layout. Indicate the positioning of type and illustrations with loose strokes.

ROUGH LAYOUTS

Although a thumbnail is already a rough design, the term *rough layout* is reserved for a more finished drawing, done to full scale. This layout may be presented to a client for preliminary approval, but it is not as tightly finished as a comprehensive layout. Usually, rough layouts are based on thumbnail sketches that have been reviewed within the agency. (It is very rare for a client to see a thumbnail sketch.)

To execute a rough layout, first take a pencil and rule up a page to the actual size of the final design. Working from the thumbnail sketch, roughly block out all of the design's elements with a pencil and kneaded eraser.

Generally, you specify text within a rough by loosely hand-lettering headlines and subheads and indicating body text with straight, horizontal lines or wavy squiggles—a process called *greeking* (see page 104). At this point you want primarily to show the overall shape and density of the type. Don't waste your time carefully drawing individual letters.

Depending on your preference, use markers and pens with various nib sizes to complete the linework. Then erase any excess pencil lines. Rough layouts are usually executed in black and white; color is ordinarily reserved for more finished comps.

Once a layout has been completed, there are various ways to present it. You can simply present the page as is, or you can staple the layout to a larger piece of bristol paper to make it sturdier and the images more opaque. For a more formal presentation, you can mount the layout on bond paper, trim it to size, and then mount it on illustration board.

These rough layouts are refinements, drawn to actual scale, of two of the thumbnails on page 87.

COMPS

Comps are finished layouts approximating the detail of the final design. They are used to make the customer enthusiastic about the ad idea and to gain final approval. With a comp, all the information is included; little is left to the client's imagination.

Agencies use a comp artist to craft an art director's rough concepts into a polished presentation. In giving an assignment, the art director may provide the comp artist with reference material from "swipe" files (artwork or photography taken from magazines or reference books). The art director may also have specific instructions about the style and mood he or she wants to convey to the client. Often, the comp artist is hired specifically for his or her personal technique.

A cautionary note: When showing the client a comp, it is important not to give a false idea of the visual treatment by using too rough an approximation of an illustrative element. If, for example, you intend to photograph a particular setup, the comp should show the objects in the correct position. Otherwise the client may complain about the differences between the comp and the finished piece.

Rendering a Comp

The tools and materials used for comps are quite basic. As with rough layouts, the drawing surface is layout paper. The comp artist's staple is the marker. Fine points are ideal for linework; broad nibs are good for filling in large areas of color.

Working at a fast rate, comp artists can create broad sweeps of color with a wet-on-wet technique. They may at times use their fingers to smear and blend colors, especially if the marker begins to dry. For the

It is important for a comp to convey the specific style or mood of the final piece as closely as possible, as shown in this detail of the comp on page 91.

most part, colors are built up in layers, from light to dark. To add richness, detail, and fine touches of color, many artists embellish their marker illustrations with colored pencils or gouache. Some also use an airbrush for special effects.

The comp artist may work directly on a ruled-up surface or may create the artwork on separate pieces of layout paper, trim them to the correct size and shape, and then glue them into position on a base paper. The latter method is preferred because of its flexibility. If the art director wants to change the design, it is relatively easy to reposition the elements. Also, it is easier to get clean edges by trimming a rendering than by trying to stay within ruled lines.

Another important component of a comp is transfer lettering (see page 34), which is used to show the type in headlines. Working on a hard surface, all you do is rub the back of the transfer sheet with a burnisher, and the type is released from the film and adheres to the layout. Properly spaced and aligned, dry transfer type can be used for the printed piece.

Another method for placing type or art in a comp is to photostat the image on clear acetate, spray it lightly on the back with spray adhesive, and then lay it directly on the surface of the comp. With this technique, as with transfer lettering, you are limited to black as a color.

To show reverse or color type, you can use Letraset's "INT" products to create your own dry transfers in a limited range of colors. In situations where you need the type on clear film, you can use Letraset's "Color Key" overlays, which are available in selected colors.

Yet another method is to request customized transfers from a type or production house, which directly applies the type or art onto the comp or piece of stock provided by the designer. These screen-printed transfers are available in any PANTONE color and thus give the most precise idea of the printed piece. They can, however, be expensive.

Colored paper, which comes in a wide selection of tints and textures, is often used for comps to indicate broad areas of solid color. The most popular papers are those made by PANTONE, which are available in matte and glossy finishes to match PANTONE ink colors. Matte papers approximate printing on uncoated stock and glossy papers printing on glossy stocks. The papers come with a self-adhesive backing to make application simple.

Final Presentation

Most final comps are mounted on presentation board. Dimensional pieces such as brochures are folded and assembled—to be leafed through as if they were finished pieces. The most professional way to present these pieces is to create an acetate pocket for the brochure, attached directly to a presentation board.

Comps are fragile because the artwork or transfer lettering may peel off or get scratched. To protect them from damage, cover the entire surface with a piece of thin acetate lightly spray-glued at the edges. Not only does the acetate protect the comp from scratches, tears, and spills, it gives the work a finished look. Neatly prepared, professional-looking comps can help convince a client to buy an idea.

If you've hesitated
to try the Rosewood Cafe,
here's an end
to all reservations.

ROSE
WOOD
CAFE

In a comp, the artwork and type elements must be in the exact position you intend so that the client knows precisely what to expect in the printed piece.

STORYBOARDS

Storyboards present the main action of a television commercial frame by frame to the client. The number of frames may vary: nine is an average figure. Obviously, the action is highly condensed.

Creating the Storyboard

The storyboard process begins with the art director and copywriter determining the content of the individual frames. The art director then determines the viewpoints and camera angles, as well as the product features to be highlighted. These ideas are sketched out for the comp artist, who then tightly renders the boards according to the art director's roughs.

Art directors often give the artist scrap materials that illustrate exactly what is needed. For example, if a scene calls for three women of different ages standing together, the art director may provide actual photographic examples of the character types he or she envisions, including the style and color of clothing they're wearing, the expressions on their faces, and their surroundings. These specific guidelines help the comp artist to render the storyboard as close to the art director's vision as possible.

When planning the content of a

For a storyboard, the art director will present the artist with a rough sketch of the most effective actions and characterizations to convey the idea for the television commercial.

Broad shot of announcer and subject in restaurant for coffee-tasting test.

Closeup of two pots and mugs (A and B) of coffee.

Tasting coffee B, the woman has a pleasant face.

Tasting coffee A, the woman looks very happy.

Announcer leans in and asks if we can tell which coffee is best.

Closeup shot of product (can) and steaming mug of coffee.

storyboard, keep one crucial rule in mind: never promise on paper what you can't deliver on film. Because it is easy to alter reality in a drawing, you may end up showing something to a client that you can never produce. For example, if you envision a perfect sunset or a 70 mile-per-hour wind, remember that nature may not be so cooperative. An artist can render a smiling cat happily skipping across the floor, but no cat is ever going to smile—if your action is dependent on this special effect, then your commercial will be impossible to produce. In your head, visualize the ad on a television screen; then determine whether it is possible to produce it.

Format and Presentation

Every agency has its own preferred method for creating and presenting storyboards. The art director usually determines the number of frames needed for a presentation. The overall board can be drawn either vertically or horizontally. Individual storyboard frames range anywhere in size from 1×2 inches (2.5×5 cm) to 1×2 feet (30×61 cm) depending on the type of presentation needed. For example, if tclient in a big room, you may want the powerful impact

The finished storyboard has rectangular spaces, in which the voiceover or dialogue can be typed.

of oversized visuals with large type (indicating voiceovers). For a less formal meeting with a familiar client, smaller presentations suffice.

There are a variety of ways to organize a storyboard sequence. For a simple commercial, you might draw a few key frames with dialogue written underneath to give a general idea of the commercial's content. If, however, the spot requires complicated camera angles and diverse locations, you may need to work up a more detailed presentation, showing a step-by-step progression of the individual frames within the commercial.

Styles of presentation also vary. Some agencies encourage comp artists to draw outside of the frames to illustrate a dramatic action—for example, letting the image burst out of the frame. Other agencies prefer to keep the image within the frame.

Storyboards are almost always presented in color. When selecting colors, it is better to approximate reality than to use a nonrealistic color palette. Don't draw a person with a blue face, for example, unless it is your intention to apply blue makeup in the commercial. However, it is very important to use your colors as effectively as possible to evoke a mood or to make an image sparkle. Sometimes a client will have specific color guidelines, but otherwise use what you want to see on film.

The finished storyboard is mounted in a black frame containing television-shaped windows. The dialogue can be placed beneath the individual action frames. For presentations to a large group of people, however, it is most effective to use a tape or an announcer to relay the dialogue.

Action and Motion

Storyboards are visual narratives. And the way you compose and organize individual frames is vital when telling a story. Since you are working within the limits of a two-dimensional format, you may need to give the action on the storyboard added emphasis to convey its impact. If you are planning certain camera effects such as zooms and dissolves, exaggerate your images to make them "pop."

When creating storyboards, you are doing the job of a film director. You must calculate the ideal camera angles to present a scene. A dramatic or exaggerated camera angle can immediately convey a specific mood or emotion. If, for example, you want to portray a man feeling alone in a room, use a long shot or an overhead shot to create a feeling of isolation. In instances where you don't use words or voiceovers with a commercial, the camera angle can tell the entire story.

ANIMATICS

An animatic is artwork filmed with a video camera to simulate a live television commercial. The "animated" art can consist of drawings that are stationary or have movable pieces; it can be shot against single or multiple backgrounds. Produced with voiceovers and soundtracks, animatics help the client envision a full-motion commercial.

Because animatics are expensive to produce, an agency doesn't normally use them to pitch a commercial idea to a client unless specifically asked to do so; storyboards usually suffice as a visual workup for a commercial. Sometimes, though, when an agency is pitching to a new client and wants to make an impression with a more developed presentation, it will go to the expense of producing an animatic.

Companies often commission animatics to test ideas. Say, for example, that an agency has three totally different concepts for selling a product. One is daring, another is sophisticated and clever, while the third is very safe. The agency will prepare three different animatics and run them by consumers for reactions, using either settings with one person or settings with a group of people. Based on the feedback, the agency can make adjustments to the commercial before it begins the actual production.

Producing an Animatic

Before art for an animatic is rendered, the agency confers with an animatics studio about production guidelines based on the budget and other requirements for the project. The studio outlines for the art director how many frames should be

drawn, what kind of action is possible, and so on. In short, the animatics studio tells the agency exactly what it can expect for its money. Animatics can be very rough or amazingly sophisticated; a rough animatic may contain only a few frames of action, while a more elaborate animatic may look like a finished commercial complete with integrated music and voiceovers.

After the guidelines for an animatic are set, the art director provides the artist with roughs or storyboards mapping out the sequence of drawings needed. The

These rough sketches for an animatic use the same storyline as the storyboard on page 93. In a rough sketch, there may be specifying directions for particular actions, voiceover dialogue, or camera angles within the animatic.

Broad shot of announcer and subject.

Closeup of two pots of coffee to be tested.

With first cup woman looks pleasant.

With second cup she is ecstatic.

Announcer leans in to ask if audience can tell which is best.

Closeup of product (can) and steaming mug.

animatic art can include movable parts with interchangeable backgrounds, midgrounds, and foregrounds, or it can consist of stationary drawings that are filmed using special camera effects to create the illusion of animation and movement. The size of the actual art can range anywhere from 3 to 24 inches (8 to 61 cm). Keep in mind, however, that the smaller the work is, the less area the camera has to move across.

To film an animatic, the studio first places the frames of artwork on an *animatic stand*. Then a top-mounted camera is used to pan through the art to create a sense of movement. For example, to simulate a person walking, the camera moves from left to right across the picture plane. To further enhance the walking motion, cutout drawings of legs can be adjusted at varying angles between frames. Artists also use cutouts to depict a change in facial expression or to add a new element to the scene.

The animatic camera is operated by very precise controls and can be programmed for specific time lapses and actions, simulating what a film camera on a dolly would do. It can zoom into an image, pull way back, or dissolve from scene to scene. In other words, the animatic camera duplicates the language of film. After the animatic is shot, the videotape is edited just like a feature film, with the editor laying down major scenes and adding dissolves, making cuts, introducing music and sound, and so on. The animatic camera can really make your storyboards come alive. And the more "true to life" a presentation is, the more convincing it is.

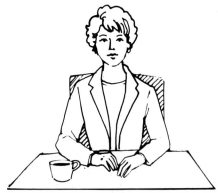

Animatics use cutouts to portray changing action and facial expressions. Here, cutouts of the figure's arm and head are inserted into a slot in the body.

PHOTOMATICS AND STEALAMATICS

If you are creating a commercial containing a number of montaged images and scenes that jump quickly from one to the other, photomatics and stealamatics are excellent presentation tools. Photomatics consist of cutout photographs (usually taken straight from magazines) that are shot in sequence on an animatic stand. By taking photographs from various sources, an art director can compile images that closely reflect scenes he or she envisions for a specific commercial. Though they don't include movable parts, photomatics, combined with soundtracks and voiceovers, are more realistic than animatics.

To create a stealamatic, also called a *ripamatic*, an art director constructs a facsimile of a commercial using footage from other commercials. A stealamatic is culled from ¾-inch (2 cm) off-line director's reels containing other films that an agency has produced (¾-inch off-line videotape is the industry format for screening film and doing edits; broadcast-quality tape is 1-inch [2.5 cm] videotape). From these reels, the art director picks out different scenes and images that convey the desired mood or message.

The downside to producing photomatics and stealamatics is that your client may become married to images that you don't plan to or can't produce. Often an agency will make a stealamatic using the very best scenes from the very best commercials, but fails to mention that this commercial will cost six million dollars to shoot. Despite the limitations, photomatics and stealamatics are effective tools for selling complicated ideas for a commercial.

7 Tricks of the Trade

The main considerations in preparing a comp or mechanical have already been detailed in the preceding chapters. Every advertising artist and graphic designer, however, discovers additional methods—"tricks of the trade"—that help to save time or to avoid common pitfalls. Indeed, there are probably as many tips as there are artists, and several books have even been devoted to tips alone (see the bibliography).

One of the most important tricks to learn is how to quickly fix mistakes. With tight deadlines, you may not have time to send out for new type. Provided that you have scrap type to work with, it's fairly simple to repair broken or missing type; you can even rebreak lines of type and change a column width. It is also possible to patch in a last-minute change in an illustration in a finished comp or make a quick revision in the color of an element at the client's request.

It's also important to discover special touches that can make your work stand out from all the competition in the field. Sometimes all you need is an exciting texture to enliven an ad. The more you experiment with your tools, the greater the variety of effects you'll be able to offer a client.

TYPE ADJUSTMENTS

Correcting Small Type Areas

There will be times when all you need to do to finish the mechanical is to replace a damaged letter or word or adjust the spacing within a line. Making these minor corrections by hand can save you time.

It is important to be neat and precise when you work with small pieces of type. Many artists find that one-coat rubber cement is the best adhesive to use for small pieces of type. First make a cutting surface by applying white tape to a piece of cardboard. Next glue the back of your repro and let it dry with the type face-down. Then turn the copy over on the cutting surface and, using a T-square or a metal-edged triangle, carefully cut out your letters or words with a razor blade or X-Acto knife (be sure that you don't nick surrounding letters). Lift the cutout with tweezers or the corner of your blade and then position it on your mechanical.

Don't glue small patches on top of repro; instead, cut a window in the repro. Working on a single layer helps you line up the old and new type; it also helps prevent the type from slipping out of place. Use a T-square or metal triangle to make a square cut in the repro. To remove the old copy, flow rubber cement thinner underneath it and then lift it off with a razor blade. Let the board dry, position the new repro, and line it up with your T-square. Finally, place a piece of tracing paper over the copy and secure the repro to the board by burnishing it.

Sometimes you may need to replace a word with a word of different length. For example, *houses* may change to *house*. To replace a five-letter word with a four-letter word, remove the old type and create a window using the method described above. Then drop the new word into the window and center it so that the spaces to the right and left are equal. If the new word is much shorter than the original word, you may have to cut up other words in the sentence and space them out.

When replacing a short word with a longer one, you will have to reduce the space between surrounding words to fit it in. Making this kind of

When replacing a long word with a shorter word, first cut the old word out of the pasted-down repro.

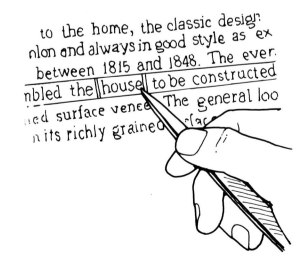

Give the new word a coat of rubber cement and center it in the window.

correction is a little tricky. Be careful not to run the words together; the type must be readable.

Some corrections to copy on mechanicals can be made without replacing repro. To remove extraneous marks or letters, simply scrape them away with a razor blade by removing the top layer of paper. You can also use black ink or opaque white paint to fill in or cover up a mark or a blemish. For example, you can use a technical pen to draw over a white spot on a black letter or create a punctuation mark.

Rebreaking Lines of Type

When you are working on a mechanical, it may be necessary to rearrange several lines of type within the layout. For example, if you delete a few words, you may need to respace a line or two. Or you may decide to re-rag a few lines set to the wrong width—especially if you don't have time to reset the copy. However, if a substantial amount of copy needs to be reworked, it is best to have it reset. With small patches of type, there is always the risk that they will fall off the mechanical.

To re-rag a small block of type, take a piece of tracing paper and draw an outline of the new dimensions or shape that you want. For instance, you might decide to make a caption 1 pica narrower. Using a pencil to experiment, scribble on the tracing paper where your breaks will occur. The last two words of the first line, for example, may move to the second line, and so on.

Now run a T-square across the bottom line of type to ensure that the block is perfectly straight. Place the T-square over the letters on the first

line, just clearing the top, and cut a "hair" above the type straight across. Move to the next line and cut above the letters at exactly the same place, and so on for the entire block of type.

Next, following the tracing that you have made, rebreak the type lines. If you cut each line precisely to begin with, it is easy to move type from one line to the next and maintain even leading. Getting the correct

Using a T-square for a guide, cut in between the lines of type at precisely the same place throughout the copy block.

Follow the tracing on the tissue overlay to rebreak the lines of type.

word spacing is a matter of training your eye. If you're not sure about what you've done, make a photocopy to check.

Using Plate Bristol Paper

Though type is normally pasted directly onto a board, if a good deal of cutting is going to be done, it is wise to first glue the repro onto a piece of plate bristol paper, which can later be pasted onto the mechanical. Bristol paper holds wax and rubber cement well and is thick enough to withstand knife cuts. By making the type adjustments on the plate bristol paper, not directly on the board, you have the flexibility to move the repositioned type as a unit rather than piece by piece should you decide to rearrange elements again.

Special Type Adjustments

If you want to make a line of type *curve*, it is relatively easy to do this by hand. First, lightly pencil in the curve you want. Then make vertical cuts between the letters in your line of type so the repro is flexible enough to curve. Do not cut all the way through, however. If you want the letters to curve upward, make your initial cuts on the lower part of the letters. Then cut notches between the tops of the letters. Lay the type along the curve and use tweezers to adjust individual letters.

To *center* different type elements (such as headlines, subheads, and body copy) on a page, measure the exact center of the element with a ruler and indicate it with a tick mark in nonrepro blue. Next draw a nonrepro blue line down the exact center of the page; then align the tick mark with it.

For extensive corrections, work on plate bristol paper and paste the plate bristol directly on your mechanical.

With the type upside down, cut notches between the tops of the letters. Cut away from the type rather than toward it.

Using tweezers, fan the type out along a drawn line of the curve you want.

101

Drawing precise rules, borders, curves, and circles directly on a mechanical or a piece of art requires a steady hand. Using a technical pen, special compasses, and straightedges, you can learn to create perfect lines every time.

Rules

Before you attempt to draw on your final surface, it is a good idea to make a few practice strokes with your pen on a piece of scrap paper. Make sure the ink is flowing properly and that the line thickness is correct for the drawing.

Before you draw a rule in ink, lightly indicate the line in pencil on your layout. Next, place a straightedge just below the pencil line. Then slightly angle the pen backward, toward you, against the straightedge so that it is touching the pencil line, creating a small space between the pen and the supporting edge. Using gentle pressure, slide the pen along the straightedge in one steady motion.

It is important to slant the pen correctly so that the ink doesn't flow underneath the straightedge onto the paper or board. Also remember that if you tilt the pen too far back, your ink won't flow smoothly and the line may be broken or too thin.

To draw a vertical rule, either use a triangle against a T-square or rotate the paper 90 degrees. Draw the line away from your body. Many artists prefer drawing against the left edge of the triangle because it allows a more natural drawing motion.

Thick Rules

Sometimes you may want to draw a rule that is thicker than any of your technical pen nibs. The easiest method is to build the line with a series of strokes. Start by ruling two parallel lines to the thickness and length of your final rule; close off the ends of the rule with two more parallel lines. Then fill in the space between the lines with your technical pen. Or, if your rule is especially thick, use an inked brush.

Circles

You will need a compass for drawing precise circles. Use a technical pen attachment with a drop compass for small circles and a compass with an extension arm for very large circles. Before inking a circle, establish its diameter on a scrap of paper.

Find the center of the circle with the compass needle and extend the drawing arm to the proper radius. Hold the compass with your thumb and your index finger and then swing it in a clockwise circle that pivots on the needle. When you feel comfortable with your drawing motion, lower the compass arm onto the paper surface. Draw with a smooth, uninterrupted motion until you complete the circle just beyond its starting point. When you are finished, clean the compass so that ink doesn't accumulate on it.

Inking Rounded Corners

Rounded corners consist of symmetrical curves that connect precisely with the straight lines on each side. Creating rounded corners is an exacting inking feat.

To establish a perfect curve, begin by indicating the final square or rectangle in pencil. Using a 45-degree triangle, draw a diagonal line that bisects the corner of the box. (You

can also find this diagonal by drawing a square at the corner and then drawing a diagonal line between the opposite corners.)

To indicate the rounded corner, place the needle of a compass anywhere on the diagonal line, with the pencil touching the straight lines of the corner, and draw the arc in between. Where you place the compass on the line will determine the degree of the curve. Use this procedure for each corner.

To ink the rounded corners, begin with the curved lines. Place the compass needle in the hole you made earlier, when drawing the pencil lines, and follow the same curve. Only draw up to the points where the curved and straight lines intersect. Ink all four corners in this way.

Now do the straight lines. Using a T-square, line up the end of the curved line with the straight line. Start your straight line at the point of intersection in order to blend the inked lines together. Take care to maintain an even line thickness.

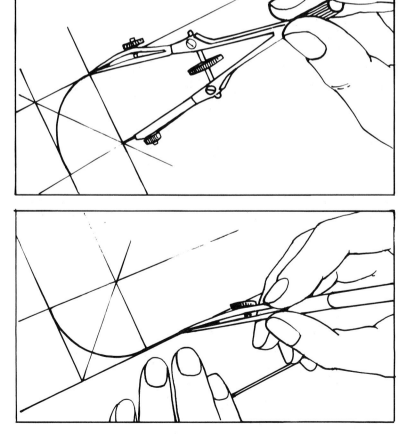

Do practice strokes on a scrap of paper to obtain the line thickness you desire.

Use an inking compass to draw perfectly rounded corners. Finish the straight line with a T-square and a ruling pen.

There are several ways to show text in a layout or comp without setting actual type. Depending on the degree of finish a presentation requires, you can indicate typefaces and type placement as loosely or as precisely as you want.

A popular method of approximating lines of text type is to use a chisel-point pencil matched to the x-height of the type. To make a chisel point, rub the edges of a pencil lead against a sanding block until you create the desired lead width. Then, with a T-square and a triangle to guide you, mark off the type block in your layout with light pencil lines. Place a Haberule on the paper next to the type area to calaculate the desired leading. Slide a T-square from line to line down the text block, using the chisel-point pencil to draw individual lines of type.

You can also use pairs of parallel lines to indicate text type. The upper line represents the top point of the x-height, and the lower line represents the baseline. This method is useful when you are preparing a quick layout and don't have time to carefully form a chisel point.

Another way to indicate text type is to use cursory strokes to simulate letter shapes and spacing between words. Use a pencil to create pairs of parallel lines throughout the text block as just described. Then draw freehand strokes between the parallel lines to indicate individual words. You can also simulate ascenders and descenders to create the appearance of real type.

The most exacting method for indicating type is called *greeking*. Artists use this method to closely imitate letter shapes (and even

You can draw lines of the exact width that you want using a chisel-point pencil.

Another way to indicate lines of type is with ruled parallel lines, indicating the x-height.

With cursory strokes, you can simulate letter shapes, showing the x-height and including some ascenders and descenders.

specific typefaces) without making real words. For first presentations that need to be rather tight, greeking allows you to show a client a layout or comp with near-letter quality.

Another possibility is to put down a photocopy of sample type in the typeface you intend to use. There are type sample books that show settings of common typefaces in different sizes. By using several photocopies, you can create a block of type of the width and length you want.

A more time-consuming method is to greek the letters, closely imitating the actual typeface.

Display Type

When indicating headlines and subheads within a tight layout or comp, most designers simulate the final type by spelling out actual words in the chosen typeface. Indicating display type helps you and a client closely visualize the appearance of the final design.

First determine the exact length of the line you want to indicate by counting the characters needed to fill it. Next draw a baseline on a piece of tracing paper on which the letters will sit. Find the appropriate type size and sample in a type spec book or another source, and place the tracing paper over the first letter of your line at the left edge of the tracing. (*Note:* If you don't find the right type size in your spec book, make an enlarged or reduced photocopy of the desired typeface.) Using a sharp pencil, outline this and each subsequent letter until you have completed the line. If your typeset letters will be solid, fill in the traced letters with your pencil. Finally, attach the display type to your layout.

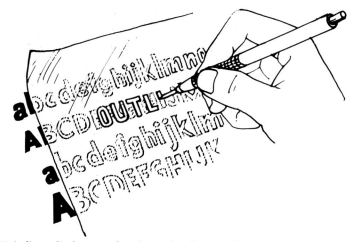

To indicate display type, first draw a baseline on a sheet of tracing paper. Align letters from your type source on the baseline and trace their outlines.

POSITIONING LARGE STATS OR REPRO SHEETS

It can be difficult to position oversized photostats or repro sheets on mechanicals on the first try. And because the surfaces of these stats and sheets are covered with such a large amount of glue, *re*positioning them can be a nightmare. Once something is adhered and burnished to a mechanical, you may rip the paper or the top layer of the board if you try to pull the paper up. It is therefore vital to position oversized elements correctly the first time.

First place a piece of tracing paper over the mechanical and tape it at any two adjoining corners. Use a pencil to trace all components of the mechanical already in place that are relevant to the positioning of the photostat (or repro).

Next lay the unglued photostat beneath the tracing paper in the exact position you want. Although at this point the stat should not be fully trimmed, it is best to trim it within an inch or so of the final size so that it is more manageable.

Adhere the face of the photostat to the back of the tracing paper with two small pieces of tape. Then, fold the tracing paper backward off the mechanical onto the drawing surface. Glue the back of the photostat with rubber cement. Because the stat isn't yet trimmed to exact size, it isn't necessary to glue it right to the edge. In this way you can avoid getting glue on the tracing paper.

Once the glue is dry, gradually fold the tracing paper back over the mechanical's surface to position the photostat. To avoid trapping air bubbles underneath the paper, *slowly* and carefully press the photostat onto the board.

Finally, remove the tracing paper and trim the stat to size. The tape that held the elements in position will be trimmed away with the excess paper.

Positioning large stats or repro sheets is simplified by keying your art to a tracing paper flap before adhering it to the board.

Positioning Art or Type

Triangles can be used for purposes other than drawing a straight line—for example, to slightly reposition an illustration or type block on a mechanical. First place a piece of tracing paper over the mechanical and trace the elements that you want to reposition. Then move the tracings around until you find the correct placement. Put a piece of tape at the top of the tracing and secure it to the board.

Now put rubber cement on the back of the type or illustration and then cut it out (gluing first prevents buildup on the edges). Place three-quarters of the repro on a plastic triangle, hanging the top quarter over the edge of the triangle. The triangle acts as a barrier between the repro and the mechanical board, so you can experiment with position without sticking problems.

Lift up the tissue paper and move the triangle around underneath to match the traced outlines. Then, with your thumb, press down the quarter of the repro at the top of the triangle and slowly pull the triangle out from underneath the repro, pressing as you go. You can also use a triangle to mount photographs to a board or to adhere repro to acetate.

Drawing Parallel Lines

If you don't have a T-square available and need to draw parallel lines on a layout, simply use two triangles to establish a straightedge. First lay a 30-60-90 or 45-degree triangle down on the drawing surface with the bottom edge flush with the bottom of the layout and the hypotenuse on the right. Tape it in place. This triangle serves as a guide.

Now take a second 30-60-90 or 45-degree triangle and place its bottom edge against the diagonal edge of the first triangle so that the combined angles at the top add up to 90 degrees. The top edge of the second triangle is then parallel to the bottom edge of the first triangle. If you then slide the triangle down along the edge of the first triangle, you can draw repeated parallel lines.

Another method is to place the first triangle with the hypotenuse to the left and then align the bottom of the second triangle along its vertical edge with the hypotenuse down.

If you don't have a T-square, use two triangles to draw parallel lines, sliding one triangle down along the edge of the other.

A triangle is an excellent tool for mounting an image on a mechanical.

CREATING SPECIAL EFFECTS

There are many unusual textures and special effects you can create for comps or finished art. Like any artist, you should experiment with a variety of media to see what is possible. Here are a few suggestions.

To make a bumpy texture, draw with a black marker over the rough surface of a paper towel. Make a photocopy of the paper towel and then use the texture in any way you desire. For instance, you might fill in the letters of an outline typeface with a rough texture for an unusual logo. To create a faceted effect, use aluminum foil in a similar manner.

To achieve a ghosted effect with an image, place a piece of tracing paper face-down on the photocopying machine with the original face-down on top of the tracing paper. Then make a copy. The resulting image will be diffused, but still recognizable.

To further enhance or manipulate photocopied art, you can draw on the copied image with color pencils and black or white grease pencils. When the image is to your liking, you can make a photostat of the art and place it on your mechanical for position or for printing as line art.

To create a fluid, calligraphic title or type logo, try drawing letters with an ink dropper. The flow of the ink will give the letters an organic appearance without seeming contrived.

Suppose you want to incorporate a piece of torn paper into a comp. Take a piece of thick white paper and a piece of black paper, and tear them together. Place the black paper on the layout and the white paper on top, but leave the torn edge of the black paper exposed underneath the white. To create a tear for a printed piece, rip two pieces of black paper in the same way, placing the bottom piece on the mechanical board and the top piece on an overlay. Then specify to the printer what colors or tints you want each piece of paper to print.

Draw over the rough surface of a paper towel with a black marker to create an interesting texture for a logo or an artistic background.

Create your own ghosting effects by photocopying artwork through a piece of tracing paper, as shown on the right.

Tear a piece of black paper together with a piece of white paper for use on a comp. For the printed piece (right), you need to use two sheets of black stat paper, one on the base mechanical and one on the overlay.

CORRECTING COMPS

Imagine that you have worked for days to create a spectacular comp for an important presentation. All of the art and type is in place; all the pencil marks and smudges have been cleaned up; everything is ready to go. Then, as you put the cap back on your broad-nibbed black marker, the marker falls from your hand right into the white area of your comp. The presentation begins in less than an hour, and you don't have time to redraw.

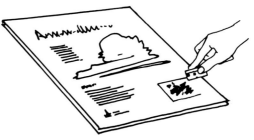

Place a sheet of clean paper behind your comp and cut out the smudge through both paper layers.

Fortunately, with a paper patch, you can restore the comp. Take a sheet of the same type of paper on which you drew the comp and place it behind the original layout. Then cut a square through both sheets of paper to remove the splotch.

Throw away the square with the splotch and lightly tape the edges of the cutout area to hold the new square in place. Turn the comp over and tape the paper patch firmly in place on the back. The hole on the front surface will now barely be visible.

Remove the splotch and then lightly tape the edges of the cutout to hold the new paper patch in place.

Often, after a comp is finished, the art director or client will suggest a small change—for example, asking you to change a pair of red shoes to green shoes. To fix a clearly defined area like this, you can make the correction on a separate piece of paper, cut it out, and then attach it with spray adhesive.

Turn the comp over and firmly tape the paper patch in place. Then remove the tape in front.

Simulating Varnish on a Black Surface

If you are designing a piece that has a black cover, you can suggest the effect of spot varnishing in your comp. To do this you need a stat camera.

Shoot the image, pattern, or type you want to spot varnish as a positive line stat at the desired scale. Stats are made using positive and negative papers. Run both the positive and negative papers through the processor. (*Note:* This process is most effective when the chemicals in the processor are old.)

Wait 1½ minutes and then peel them apart. Dispose of the positive stat. Rinse the negative paper under water and allow it to hang dry. The negative paper, onto which the image has been exposed, should show a trace of the original image as a shiny area against the matte black of the paper itself, closely approximating the look of a varnish.

Cleaning Up Reverse Stats

With a reverse stat, where the background is black, you don't want any edges or cut marks to show as white lines when the piece is printed. To prevent this, use a black marker to color the edges, as well as any cut marks, black.

Creating Corners with Tape

When you use border tape to create a box, it is important to get sharp, clean corners. Before you put the tape down, draw the box lines in nonreproducible blue. Then put a length of tape down that is slightly longer than the line you want. For the intersecting line, again lay down a piece of tape that is slightly longer so that it overlaps the first piece of tape. Now, using a razor blade or X-Acto knife, cut through both layers of tape at a 45-degree angle at the corner. When you remove the extra tape, you should have a sharp corner.

To create a clean corner, cut through both layers of tape at a 45-degree angle. Then remove the excess tape to reveal a sharp corner.

DESIGNING A GRID

A grid provides a foundation for a design and helps you to establish visual continuity throughout a piece. To some extent, designing a grid for page layouts is a subjective process. There are many ways to design the grid depending on the type of flow you want for your copy and art. For one piece, you might opt to soothe readers with a pleasing symmetry. For another, you might want to jar them with asymmetrical or discordant relationships between elements on the page.

To create a classically balanced design, you must maintain constant proportions throughout your piece. Let us say that, in addition to the text type, you have four levels of type on a page: a display header, a headline, subheads, and captions. Now you must create constant ratios between the line widths of these elements. One common rule is to work in ratios of thirds, giving the whole a clear mathematical balance. For instance, if the display header runs 9 inches across, then the headline would run 6 inches wide, the subheads 3 inches, and the captions 1 inch.

To create a more dynamic design, you might vary the ratios between elements. For example, the header might again be 9 inches, but the headline would be 7 inches, the subheads 4 ½ inches, and the captions ⅞ inch wide. Here there is no proportional logic to the descending order of the widths; instead, an aesthetic interest is created by the odd relationships between the type elements.

The same rules can apply to type columns. While evenly spaced and proportioned columns establish a symmetrical constancy from page to page, unequal columns can set up a dynamic use of space. For instance, you might use a narrow sidebar on the right side of a spread, with three text columns on the left page and only two on the right.

Another way to jolt the viewer is to position page elements in unusual relationships with one another. For example, a headline might cross into the next page and partially intrude into a column of type.

The pages opposite show some of the possibilities with the grid of two 12½-pica columns and one 9-pica column (below) used for this book.

Drawing Table
The drawing table is the graphic artist's work surface. Carefully choose the one that you'll be most comfortable with. A range of sizes and styles are available from the classic, wooden standard to a state-of-the-art pneumatically raised and lowered model. To best suit your specific drawing needs, the table top should be adjustable to various heights and angles.

Drawing Board
Boards can be used free of a stand or placed on the drawing table to preserve its surface. To ensure precision T-square work, they must have perfectly squared sides. Metal T-square guides can be clamped on the board's edges if it becomes warped or worn.

Taboret
This is a storage unit for artist's materials. A perfect work station and organizer, the taboret has utensil drawers, storage wells, and shelves.

Light Box
The light box consists of a frosted glass or plastic top held within a

frame and illuminated from below by fluorescent tube lights. It can be used for viewing photographic slides and transparencies, evaluating color separations, tracing material from photographs or illustrations, and registering overlays. Many styles are available from the mini-portable to the light table on a stand to the wall viewing model.

Flat File
A flat file is perfect for preserving, organizing, and storing your work. Made of metal or wood, it generally consists of five-drawer sections with inside drawer sizes ranging anywhere from 26" × 20" to 50" × 38".

Lamps
Proper lighting is vital for the work area. An adjustable-arm fluorescent lamp that clamps on to your drawing board allows you to direct the light edges that prevent technical pens from seeping underneath. Solid steel triangles have precision, machined edges ideal for cutting against. A steel edge plastic triangle can be used for inking as well as cutting.

can be used for inking or lining up type. Pica measures and conversion type rules are used for measuring type and calculating widths and depths of text matter (may include in me-

counterweight, tooth-and-gear, or steel bearing systems that slide the straight-edge evenly up and down the board's surface.

Triangle
Used along with the T-square or parallel motion unit, the right-angled plastic triangle enables you to construct perfect angles and draw perpendicular lines. The most common sizes are 45 and 60 degrees. Calibrated for angles 0 to 90 degrees, the adjustable triangle is very useful for

T-Square
One of the most essential graphic design tools, the T-square enables you to draw precise parallel horizontal lines by holding its head against the left edge of the drawing board.

T-square devices called parallel motion units operated by cross-wire, counterweight, tooth-and-gear, or steel bearing systems that slide the straight-edge evenly up and down the board's surface.

Triangle
Used along with the T-square or parallel motion unit, the right-angled plastic triangle enables you to construct perfect angles and draw perpendicular lines. The most common sizes are 45 and 60 degrees. Calibrated for angles 0 to 90 degrees, the adjustable triangle is very useful for doing detailed drafting, charts, graphs and diagrams. Inking triangles are made with raised outside inking edges that prevent technical pens from seeping underneath. Solid steel

on specialized graphic arts rulers is data for advertising and printing signs and symbols.

The 12 or 18 inch (300 or 450mm) ruler is an essential tool for measuring, cutting, and drawing. The three standard scales are inch, pica and agate, and are usually found on one

The 12 or 18 inch (300 or 450mm) ruler is an essential tool for measuring, cutting, and drawing. The three standard scales are inch, pica and agate, and are usually found on one ruler. A heavy straight edge

draw parallel lines at adjustable distances. Included on specialized graphic arts rulers is data for advertising and printing signs and

on specialized graphic arts rulers is data for advertising and printing signs and symbols.

Drawing Table
The drawing table is the graphic artist's work surface. Carefully choose the one that you'll be most comfortable with. A range of sizes and styles are available from the classic, wooden standard to a state-of-the-art pneumatically raised and lowered model. To best suit your specific drawing needs, the table top should be adjustable to various heights and angles.

Drawing Board
Boards can be used free of a stand or placed on the drawing table to preserve its surface. To ensure precision T-square work, they must have perfectly squared sides. Metal T-square guides can be clamped on the board's edges if it becomes warped or worn.

Taboret
This is a storage unit for artist's materials. A perfect work station and organizer, the taboret has utensil drawers, storage wells, and shelves to keep essential tools within easy reach.

Light Box
The light box consists of a frosted glass or plastic top held within a frame and illuminated from below by fluorescent tube lights. It can be used for viewing photographic slides and transparencies, evaluating color separations, tracing material from photographs or illustrations, and registering overlays. Many styles are available from the mini-portable to the light table on a stand to the wall viewing model.

Flat File
A flat file is perfect for preserving, organizing, and storing your work. Made of metal or wood, it generally

to draw precise parallel horizontal lines by holding its head against the left edge of the drawing board. Many drawing boards have attached T-square devices called parallel motion units operated by cross-wire, counterweight, tooth-and-gear, or steel bearing systems that slide the straight-edge evenly up and down the board's surface.

Triangle
Used along with the T-square or parallel motion unit, the right-angled plastic triangle enables you to construct perfect angles and draw perpendicular lines. The most common sizes are 45 and 60 degrees. Calibrated for angles 0 to 90 degrees, the adjustable triangle is very useful for doing detailed drafting, charts, graphs and diagrams. Inking triangles are made with raised outside inking edges that prevent technical pens from seeping underneath. Solid steel triangles have precision, machined edges ideal for cutting against. A steel consists of five-drawer sections with inside drawer sizes ranging anywhere from 26" × 20" to 50" × 38".

Lamps
Proper lighting is vital for the work area. An adjustable-arm fluorescent lamp that clamps on to your drawing board allows you to direct the light anywhere you choose.

T-Square
One of the most essential graphic design tools, the T-square enables you to draw precise parallel horizontal lines by holding its head against the left edge of the drawing board. Many drawing boards have attached T-square devices called parallel motion units operated by cross-wire,

chanical tools section). The

parallel ruler helps you

draw parallel lines at ad-

justable distances. Included

113

CREATING A DUMMY

For a long document such as an advertising brochure, there are two overall design concerns: each page must work individually, and there must be a visual rhythm carrying the reader from the first page to the last. It is vital to plan your design with thumbnails and rough sketches.

Doing thumbnails is like loosening up your arm before you pitch a baseball. When thumbnailing a design, it is important to sit down and *play* with a pencil and paper, allowing yourself free conceptual reign.

Begin by plotting the content of the pages with mini page layouts. Next, sketch thumbnails for each page to indicate the placement and flow of copy and art elements throughout the document. Create many different versions to give yourself diverse options. At this stage it's best not to work with real type because you may subconsciously lock yourself into a type treatment before you have planned the whole.

After you (and the art director) are satisfied with the page layouts, make a full-size rough indicating real type and art, including heads, subheads, blurbs, captions, body copy, photographs, and other images. (If you have a Macintosh computer, output different type treatments.) Because relationships between page elements usually change when you enlarge a thumbnail to full size, experiment freely with type and art until you refine the layout.

Now give yourself a fresh view of the layout by creating a "storyboard" from your pages. Take the full-size roughs, photocopy them down to approximately 3 × 5 inches (8 × 13 cm), and lay them end to end. Taking a look at reduced-size roughs in this way can be likened to a painter who squints at an artwork in progress. What you want is an overview of the contrasts, ratios, weights, and relationships between page elements. Check that the type and art flow as you planned from page to page. Are there any unwanted starts or stops? Once you are satisfied with your design, proceed to the final comps or mechanicals.

Designers at Spy *magazine created the rough sketches (below) and more finished versions (opposite) to dummy part of an issue. Note how they vary the placement of type and art elements on each spread to establish a visual flow from page to page.*

ADDITIONAL TIPS

Substituting Thumbnails for Full-Size Layouts

If you are asked to present a comp for a rush presentation, one shortcut is to use a photocopy or photostat of a thumbnail sketch enlarged to full size. Of course, your thumbnail must be in proportion to the final layout for it to enlarge to the correct size. And it must be big enough for the blown-up version to be legible.

Enlarging a thumbnail can create interesting visual effects, which may enhance your layout. For example, linework becomes fluid and painterly, and tones begin to take on a grainy appearance.

Checking Stat Sizes

Some jobs involve a large number of position stats. It is important to check that the stat house has sized the images correctly, but with a lot of stats, this can become a time-consuming chore.

To save time, before you send the photo to the stat house, take a ruler and indicate a 100-pica measure on the margin of the photo. Then, when the stat comes back, you can check its accuracy by checking the reduction of the 100-pica measure. If you specified that the photograph be shot at 75%, the measure on the stat should be 75 picas.

No-Bleed Color Comps

It can be difficult to incorporate color into full-size rough comps that are executed with black alcohol-based markers. When you overlap the lines, the colors bleed together on the page and on the nibs of the markers themselves. To avoid this problem when creating a rough color layout, simply turn the layout over and apply the color to the back. Because the paper is translucent, the color will seep through to the front without blurring your black lines and ruining your markers. Use black markers on the front of the comp to outline the color.

By enlarging a thumbnail to full size, you can create a quick comp. (It is important for the thumbnail to be in correct proportion to the final layout.)

Super-Stick INTs

To ensure that INTs adhere more securely to your comps, apply a light coating of spray adhesive to the adhesive surface of the INT. Less rubbing is required when you press the INT down onto the comp. And because you don't have to aggressively burnish the image, you will avoid the ridges that often result from applying an INT to a comp. Use a cotton swab doused with Bestine thinner to remove excess spray adhesive from the edges of the INT.

Homemade Rubber Cement Pickup

You can make your own rubber cement pickup by pouring a cup or more of one-coat rubber cement on a large piece of layout paper. Leave it to dry overnight and then roll it into a ball the next day. You will have a long-lasting rubber cement pickup.

Centering Type Proofs

When you are laying out a type dummy and want to quickly find the exact center of a type element such as a headline, fold the strip of type in half end to end, so that the beginning of the line touches the end of the line. The resulting crease will be the exact center of the type.

Drawing Hands

Hands are one of the most difficult parts of the body to draw. If you aren't great at drawing them and need a quick but fairly accurate rendering of a hand for a rough, place your own hand in the desired pose on the paper and carefully trace around it. Hold the pose, and fill in the middle by looking at the lines and shapes within your hand. Photocopy the drawing to enlarge or reduce it, and then trace the copy for use in a layout.

Photographic Collages

When you want to combine multiple images, create a collage from two or more photographs. First, make a stat of each photo and then peel the top image-layer of paper from the stat (it's best to work with thin paper in order to prevent a thick ridge). Apply spray adhesive to the back of the stats and position the separate photo images together. Use neutral gray, black, or white watercolors or photo paints to retouch and blend the margins between the various images.

Before you send a photograph to a stat house for reduction, indicate a 100-pica measure on its margin. When reduced, this guide should measure the same number of picas as the percentage you requested.

8 New Technology

The electronic studio is the graphic artist's portal to an exciting new world of communication. With a mouse, appropriate hardware and software, a monitor, a scanner, and a laser printer, you can control a project from start to finish. Using a desktop system, you can design, lay out, illustrate, retouch photographs, typeset, proof, print, and even create separations from the same electronic pages.

As design and production processes become more and more integrated, new working relationships are being forged between graphic artist, producer, and client. Through desktop publishing systems, you link up directly to digital type and information sources, typesetters, prepress services, color separators, and printers.

To outfit an electronic studio, consult with an expert about the computer software and equipment appropriate for your business. Determine what you need in terms of memory and speed, page and text formatting and editing, color capabilities, input and ouput. Do you, for example, want to scan in images? Do you intend to produce camera-ready copy, or will you use a service bureau? Your equipment should support the specific type of work that you do.

118

THE COMPUTER WORKSTATION

The first basic unit of equipment to consider is the central processing unit (CPU), which carries out your commands. There are two main models to choose from: the IBM-type computer, with which you must type in the instructions from the keyboard, and the Apple Macintosh, where you interact directly with the image on the screen.

In purchasing this basic component, you must decide on how much operating power, or RAM (Random Access Memory), you need. At a minimum you must have enough to run the software that you intend to use. About 4 to 8 megabytes is recommended for designers.

Another vital component is a hard disk with ample storage, because illustrations in design work can take up a fair amount of space. You will also want a floppy disk drive and diskettes for backup.

The next item to consider is the screen, or monitor, which comes with software to run it and a video card that connects it with the CPU. Do you, for example, want to be able to see an entire spread at once? Not only do screens come in different sizes, there are also different orientations: portrait (vertical rectangle) or landscape (horizontal rectangle). You can also choose between monochrome, gray-scale, and color monitors. A monochrome screen is adequate for type layouts and black-and-white line art. If you intend to retouch photographs or create photomontages, however, you will need a gray-scale monitor. To see color, of course, you will need a color monitor, with the capability of showing 256 colors (for which you need an 8-bit video card).

To run your computer effectively, you will need a variety of software packages—programs that define different operations to be performed by the computer. Of particular interest to the designer are word-processing programs, page makeup programs (see page 124), and drawing and painting programs (see page 128).

To input information you will need a keyboard and, with the Macintosh at least, a mouse or another drawing device. You may also want a scanner to copy information into the computer (see page 120).

For output, you will probably want a printer (see page 132). For high-resolution output, you may want to use a service bureau or explore one of the electronic prepress systems (see page 136).

Transmitting Documents
Transmitting digital information can be as instantaneous as placing a telephone call. Text, graphics, and even animation and sound can be transmitted in digital form, and then edited and changed without altering its quality. You can transmit information from computer to computer, send or receive with a fax machine, scan materials and convert them into electronic pages to be faxed, and transmit on telephone lines to output services for printing.

A modem is needed for transmitting and receiving over telephone lines. For sending, the modem converts digital data into telephone audio tones and converts the audio tones back into digital data for receiving. Before you can do this, however, you must have the appropriate software to prepare and send the information to the modem.

SCANNERS

Scanners are used to convert original black-and-white or color photographs, illustrations, and text copy into a format the computer can use and to save this information as a graphics file. Scanners come with their own scanning software. Once the image or text has been scanned into the computer's system, it can be incorporated into the body of a layout and manipulated in a variety of ways, depending on your needs.

For example, you can transform a scanned image into a related, but different illustration by using a drawing or painting program to add line, tone, or color. You can also combine different images—placing a cat's head, for example, on a human body. Scanners are sometimes used to pick up patterns from wallpaper, fabrics, or textured surfaces, which then serve as interesting backgrounds. Of particular importance are the photo-retouching possibilities once an image has been scanned in. You can, for example, remove an unsightly traffic sign. Or you can scan in a black-and-white image and colorize it.

Each of the different types of scanners available has its own advantages and disadvantages. The most important variables to consider are conversion speed and image-resolution capabilities. Scanners with higher resolution can pick up the finest details and thus provide the sharpest images.

Scanners are available with gray-scale or color-scanning capacity and range in price from a few hundred to a few thousand dollars. *Gray-scale scanners* can sense from a few to a few hundred gray tones. They scan line art, and some can convert grays into a series of black-and-white dots (rather than gray dots) to approximate continuous tones. *Color scanners* are more expensive and more sensitive than gray-scale scanners. Some color scanners can sense millions of shifts in color.

Both gray-scale and color scanners are supplied with scanning software enabling you to regulate information such as brightness, contrast, or color qualities. These software tools help you to manipulate detail within an image and improve its general quality. In addition, most page-makeup scanning software can convert continuous-tone images into halftones and allows you to adjust the percentage of the screen, varying the line angle and lines per inch. Some programs also allow you to flop the image.

Hand-held Scanners

Hand-held scanners are convenient for copying small pieces of art and text such as logos, simple line illustrations, and type. Because hand scanners are so small, you can carry them with you to make on-the-spot scans of any flat surface from book pages to wallpaper patterns. When using a hand scanner, you must keep your hand steady and drag it with an even motion over the original. To achieve interesting artistic effects, try rolling your scanner in a backward or skewed direction.

Flatbed Scanners

Flatbed scanners operate on much the same principle as copy machines. You place your original on glass beneath a top lid and press a button. The machine then scans your image line by line. Flatbed scanners are

very popular because they are so versatile and easy to use. They can scan almost any flat image and are commonly used for continuous-tone and color photographs.

Sheet-fed Scanners
Sheet-fed scanners operate in a manner similar to fax machines; you place your original in a feeder and then rollers pull it past an inert scan head. Although sheet-fed scanners are good for scanning multiple copies of documents, the paper can sometimes be thrown out of alignment when the sheets aren't pulled through correctly.

Slide Scanners
Slide scanners translate the information on 35mm slides into the computer. They produce higher color resolution than photograph scanners and can achieve a much wider range of brightness, contrast, and color saturation than is possible when scanning reflective materials such as color prints. With a slide scanner, you can also manipulate the image. You can, for example, adjust exposure controls to the desired setting and crop and scale the image to fit your specifications.

Video Digitizers
Video digitizers convert images from video sources such as VCRs and camcorders into digital still images. These images can then be stored as a graphics file in your computer. Digitizers, aptly referred to as "frame grabbers," are available in both grayscale and full-color models.

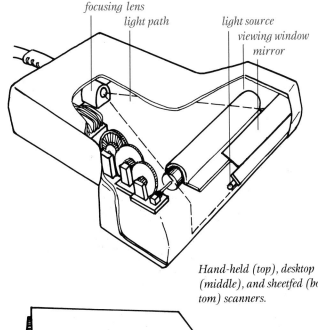

focusing lens
light path
light source
viewing window
mirror

Hand-held (top), desktop (middle), and sheetfed (bottom) scanners.

COMPUTER TYPOGRAPHY

Before laser printers were used in conjunction with a program called *PostScript* in the mid-1980s, text type from computers was limited to standard typewriter-style faces. Now PostScript, a page description language developed by Adobe Systems, has made typeset-quality text available for desktop publishing. The type can be output on either low-resolution printers for proofing or high-resolution imagesetters (see page 132) for camera-ready copy.

Using type in digital form, you can order fonts from a computer supplier and program any available typeface into your software. Many designers favor the Macintosh for typographical layout and manipulation. One reason is that with the Macintosh you can actually see the font you choose on the screen—giving you a better idea of just what you are working with before you commit to a final type design.

Most of the aspects of type discussed in chapter 2 apply to computer type—the main difference is that on the computer there is little need to do copyfitting. Instead, you can easily "set" the text in the typeface and size you want and then see on the screen if it fits. If the copy is too long, you can select a smaller size or tighter line spacing and in no time the type will be reconfigured on the screen. Should you decide a different typeface is called for, you simply select a different font and, again, the type changes before your eyes on the screen. The advantage here is that with the computer you can interact immediately with your design, without the time and expense of asking the typesetter for revisions. The danger, however, is that you won't take

care with your initial specifications and will rely too much on your ability to try out different possibilities on the computer.

Another area where the computer saves time is with runarounds. The traditional method of speccing type for a runaround (described on page 33) requires a number of calculations. In contrast, with a desktop program, if you scan the image into the computer and position it on the layout—or even if you draw the image's shape in place—the computer will reconfigure the type around the image. In other words, the computer does all the calculations for you.

Still another benefit of digital typesetting is the increased flexibility in choosing type size and spacing. Traditionally, type was available only in whole-number point sizes (9 points, 10 points, and so on). Now it is possible to have a fraction of a point size. This text, for example, is set in 9½-point Esprit, as 9-point looked too small and 10-point did not provide enough characters per pica to fit all the copy in. Similarly, line spacing can now be varied in fractional increments—all of which increases your control over a design.

If you do set type on your computer, you will need to observe certain typographic standards. Poor letterspacing or poor word spacing are common problems. The software has controls for these that may need adjusting. If the letterspacing problems are restricted to a few letter pairs, you may need to kern these pairs (see page 28). With poor word spacing, you may want to adjust the hyphenation rules or use a ragged rather than a justified alignment, as discussed in chapter 2.

Designing Type

Some computer typesetting programs allow you to design your own fonts, characters, and symbols by tracing scanned images or manipulating existing graphics or typefaces. To design an original logo for an ad or letterhead, for example, you might create characters from existing artwork and then store them in a file. If you assign a specific character or image to a key on the keyboard, by hitting that key, you can call up the image from its special file and then size it or position it any way you please.

With computer programs not only can you design new alphabets, you can also distort type in a variety of ways—slanting it, elongating or condensing it, twisting it, rotating it, and the like. You can run the type along a curve or a diagonal—or in almost any configuration you can imagine. For an initial cap, you might create a shadow effect, combine varied patterns, or fragment the letter in a modernistic design. Because the Macintosh allows you to see the letter as you alter it, you can fine-tune it until you have exactly what you want.

A computer allows you to manipulate type in a variety of ways, as shown in the examples here.

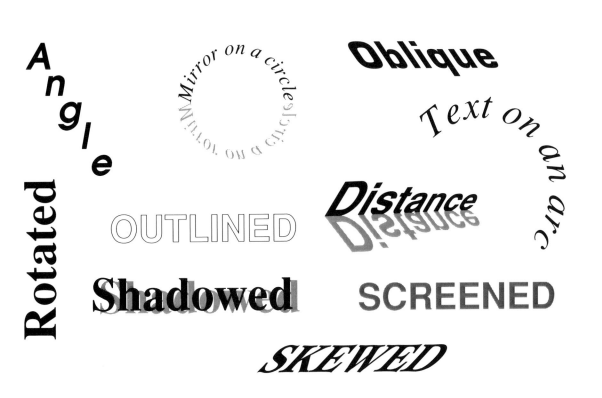

COMPUTER LAYOUT

Desktop publishing has dramatically changed the way publications and camera-ready layouts are produced. Using an electronic page makeup program, such as PageMaker, Design-Studio, or QuarkXPress, you can thumbnail, lay out, comp, finalize, and even produce the actual publication within your system. In addition, adjustments and corrections to type or graphics can be made quickly at any stage.

The Macintosh carries the advantage of a feature called *WYSIWYG* (What You See Is What You Get). In other words, as you make design decisions, you can immediately see the effect on the screen in front.

One of the first steps in designing a layout is to establish a page grid (the "electronic pasteboard"). Once the dimensions of a page have been plotted, you can combine text, graphic elements, and scanned images from different files and sources and move them around the layout at will. The computer allows you to design each page separately or to create a master style sheet for longer publications with specifications for text type, headings, paragraph indents, hyphenation, and even text colors.

One of the biggest advantages of designing on the computer is the ability to experiment freely when positioning text and graphic elements on a page. Working on the pasteboard on your screen, you can

This two-page layout was done with QuarkXPress. The grid was first established as a master page, which then served as a template. Folios and running heads or feet can also be put on a master page, so you don't have to recreate them each time.

SPEED Desktop publishing has dramatically changed the way publications and camera-ready layouts are produced. Using an electronic page makeup program, such as PageMaker, DesignStudio, or QuarkXPress.

STRENGTH
You can thumbnail, lay out, comp, finalize, and even produce the actual publication within your system. In addition, adjustments and corrections to type or graphics can be made quickly at any stage.

SPEED Desktop publishing has dramatically changed the way publications and camera-ready layouts are produced. Using an electronic page makeup program, such as PageMaker, DesignStudio, or QuarkXPress.

STRENGTH
You can thumbnail, lay out, comp, finalize, and even produce the actual publication within your system. In addition, adjustments and corrections to type or graphics can be made quickly at any stage.

SPEED

Desktop publishing has dramatically changed the way publications and camera-ready layouts are produced. Using an electronic page makeup program, such as PageMaker, DesignStudio, or QuarkXPress.

STRENGTH
You can thumbnail, lay out, comp, finalize, and even produce the actual publication within your system. In addition, adjustments and corrections to type or graphics can be made quickly at any stage.

Desktop publishing has dramatically changed the way publications and camera-ready layouts are produced. Using an electronic page makeup program, such as PageMaker, DesignStudio, or QuarkXPress, you can thumbnail, lay out, comp, finalize, and even produce the actual publication within your system. In addition, adjustments and corrections to type or graphics can be made quickly at any stage.

Desktop publishing has dramatically changed the way publications and camera-ready layouts are produced. Using an electronic page makeup program, such as PageMaker, DesignStudio, or QuarkXPress, you can thumbnail, lay out, comp, finalize, and even produce the actual publication within your system. In addition, adjustments and corrections to type or graphics can be made quickly at any stage.

Desktop publishing has dramatically changed the way publications and camera-ready layouts are produced. Using an electronic page makeup program, such as Page-Maker, DesignStudio, or Quark XPress, you can thumbnail, lay out, comp, finalize, and even produce the actual publication within your system. In addition, adjustments and corrections to type or graphics can be made quickly at any stage.

For a New Look

Desktop publishing has dramatically changed the way publications and camera-ready layouts are produced. Using an electronic page makeup program, such as PageMaker, DesignStudio, or Quark XPress, you can thumbnail, lay out, comp, finalize, and even produce the actual publication within your system. In addition, adjustments and corrections to type or graphics can be made quickly at any stage.

For a New Look
Desktop publishing has dramatically changed the way publications and camera-ready layouts are produced. Using an electronic page makeup program, such as PageMaker, DesignStudio, or QuarkXPress, you can thumbnail, lay out, comp, finalize, and even produce the actual publication within your system. In addition, adjustments and corrections to type or graphics can be made quickly at any stage.

For a New Look

Desktop publishing has dramatically changed the way publications and camera-ready layouts are produced. Using an electronic page makeup program, such as PageMaker, DesignStudio, or QuarkXPress, you can thumbnail, lay out, comp, finalize, and even produce the actual publication within your system. In addition, adjustments and corrections to type or graphics can be made quickly at any stage.

The great advantage of a computer is the ease with which you can try out different design possibilities.

place an image on the top left and then move it down and to the right if that seems necessary. You can also run text around irregularly shaped graphics, surprint or drop type out of an image, or recrop and resize an image.

For layouts in particular, page makeup programs make it easy to create variations of a design or change it. You can, for example, show the client several versions of the same layout—altering the typeface or size, or repositioning the headline or graphic elements—with hardly any extra time or expense. You can also show several different color treatments without having to

redraw. In fact, one of the problems some designers have commented on is that it is so easy to try out different arrangements that the design may not be carefully thought out beforehand. A key ability of any designer—whether using a computer or not—is the ability to visualize a design before laying it out.

Page makeup programs also allow you to look at thumbnail layouts for an entire document at a glance. These thumbnails indicate text, graphics, and line art in broad tonal areas. In this way you can quickly decide whether the flow is right or whether you want to change the rhythm from one page to the next.

Another advantage of working on a computer is the ease with which you can create runarounds. The runaround shape, however, should be relatively simple to read clearly on the page. The example here was done on a Macintosh using QuarkXPress.

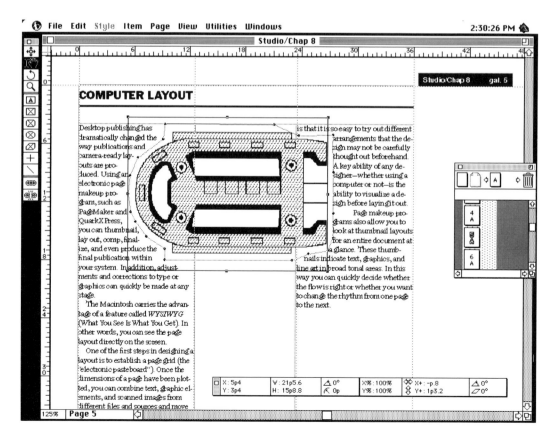

On the computer screen, you can call up a series of pages in reduced form to see how the visual flow works from one to the next. These pages were designed by Mary Moriarty.

COMPUTER GRAPHICS

Computer drawing and painting programs put an array of artistic techniques at the designer's fingertips. Pencil, pen, brush, and airbrush effects are all available. Perfect circles and straight lines can be drawn at a touch of the keyboard.

Still, computers don't replace basic talent and a knowledge of graphic techniques. Creating outstanding graphics on a computer requires good drawing skills and a designer's trained eye.

Drawing

Computer drawing programs are widely used for creating logos, schematics, line drawings, charts, and graphics. Images are drawn with a mouse or stylus in conjunction with keyboard commands that describe specific graphic coordinates. You can also trace scanned images on the screen.

Once you've drawn a shape or object, you can duplicate it, flop it, move it around, or combine it with other objects. Most important, you can save it and use it in a number of different illustrations.

More specifically, drawing programs define shapes that are object-oriented—that is, distinct from other pieces within an illustration. For example, an ellipse is an element separate from a rectangle or a curved line. These elements can be copied from one drawing to another and

This clip art has been automatically traced to give an outline image, which can be used as the starting point for a different piece of art.

manipulated as independent objects.

With most programs, to draw a straight line, rectangle, ellipse, triangle, circle, or arc, you only need to specify certain key points. The computer then calculates the points in between and draws the shape. You can also draw free-style, using the mouse like a pencil. With either method, once you have a closed shape, you can fill it with a tint or pattern. (A selection of tints and patterns is usually available in the software, but you can also create your own patterns.)

Working freehand, you can use a sketch on paper or another existing image as a guide and trace lines or shapes over it. Even if you can scan the image, you may prefer to trace it into the drawing program to avoid jagged lines and get all the details.

Painting

Paint images are composed of many little box-shaped dots, called *pixels* (short for *picture elements*). In contrast to a drawing program, where the image is built up by layering independent shapes, in a painting program the image is created by grouping pixels together. Pixels may consist of only black-and-white information, or they may contain further attributes such as color or shades of gray. The image and the individual pixels can be magnified so that small details in the art can be altered.

Black-and-white painting programs offer tools for creating a variety of lines and textures. The *paint bucket,* for example, allows you to fill in areas with either a solid black or a pattern; there is also an eraser with which you can delete black areas.

In drawing on the computer, it is best to break the image into component parts, working area by area.

With a pencil tool you can create thin or wide lines; similarly, with a brush tool you can lay down a variety of brushstrokes. Using an airbrush or a charcoal tool, you can soften an edge, lighten or darken an area, remove a spot or otherwise retouch an area, and smear or blur an image. Blending tools enable you to blend shapes and tones together. A water droplet program simulates watercolor.

As with drawing programs, there are various tools that allow you to manipulate the image. You can, for example, "lasso" it and move it around on the screen, rotate it, and flop it.

Even more options are opened up if color is at your disposal. Macintosh computers offer you the use of more than 16 million colors. Although you can't see all of these colors without a special display adapter, the color information is stored in the system.

Color painting tools offer much the same variety as black-and-white tools, with the added possibility of manipulating color. With some programs, you can push the color around much as you would do with a palette knife. Or you can use an airbrush tool and adjust the spray size and amount of color flow to create different ink effects. An important time-saver is the gradated fill, which quickly models a shape from dark to light.

Some programs enable you to adjust contrast and brightness in an image to achieve effects similar to posterization, where midtone grays are reduced to a few flat tones, creating higher contrasts of black and white. Other special effects include blurring, shaping, or silhouetting edges.

Color programs with different palettes enable you to retouch continuous-tone images scanned into the computer by painting over areas with the airbrush or watercolor tool. It is also possible to adjust the overall gradations of tone within an image by adjusting a pressure setting within the paint program. As you apply more or less pressure, the image becomes darker or lighter. However, to create high-quality color halftones, suitable for printing, you need a sophisticated program.

Paint programs are excellent for presenting ideas for television and for creating animation. You can quickly copy an image and alter its position slightly for an animated sequence. Coloring is equally simple—you just choose a color to fill an area, instead of spending hours carefully painting a cel. Another possibility is to create a three-dimensional drawing and rotate the image frame by frame as if you were using different camera angles (zooming in, pulling back, or moving in a particular direction). You can also bathe the object with various intensities of light.

There is, however, one important caveat with color: what you see on the screen is not exactly what you will get if the color is printed. The color on the screen is made with light, while printed color is made with pigment and is generally less brilliant. Also, the color distinctions on the screen are often subtler than what is possible in print.

One advantage of doing illustrations on the computer is that you can zoom in on an area to change just a few pixels, as shown in this example from Studio/8 on a Macintosh. This ability is particularly helpful in retouching small areas..

COMPUTER PRINTERS

In the early 1980s, the Apple Laser-Writer (a PostScript printing device) was the first laser printer supported by software that provided standard type fonts and graphics. With its resolution of 300 dots per inch (dpi), this laser printer enabled desktop users to output commercial-quality documents on the spot.

The laser printer works by putting positive and negative static charges on the paper. The toner sticks only to the positive charges and is then "fused" to the paper with a combination of heat and pressure. Laser printers can be used to print documents such as newspapers, newsletters, and inexpensive brochures. The output from laser printers can also be used for offset and xerographic printing, as well as for printing done on web presses.

Desktop computers can be linked up to professional imagesetting systems, which greatly decrease the expense of preparing negatives and page stripping. Laser imagesetters are high-resolution devices (1200–2400 dpi) used to print camera-ready pages on photographic paper or film, including halftones, to create plates for printing presses. They are completely digital, reproducing little dots onto film or photographic paper in order to make a negative or positive image.

Imagesetters are widely used in the printing of high-quality advertisements for books and magazines, and are vital for producing high-quality images from scanned photographs and color graphics. Though imagesetters are still too expensive for most small businesses or for the individual desktop publisher to own, through service bureaus, their high-quality output is available to any computer user.

Color Printing

Unless you use a color printer, color graphics will be printed in black-and-white. And unless you spend a great deal of money for computer-to-printer interfacers, the color reproduction you can get on a computer printer is not yet equal to that of conventional printing methods. But you can easily prepare color for electronic prepress systems (see page 136).

Color can be prepared on a printed page by the computer as a solid color (with uniform saturation and hue), a percentage of a solid tone (tint), or a halftone (continuous tone). Solid colors and tints can be composed within the computer to correspond to either PANTONE or four-color process colors. Color halftones, however, are made from the four process colors (cyan, yellow, magenta, and black).

Desktop color printers can be used to create color comps combining all the graphic elements on the page. Color printers can also be used for office document printing and for printing master pages for color copiers (if you plan to reproduce the piece by photocopying).

SPEED Desktop publishing has dramatically changed the way publications and camera-ready layouts are produced. Using an electronic page makeup program, such as PageMaker, DesignStudio, or QuarkXPress.

The top example here was run out on a printer with a resolution of 300 dots per inch (dpi)—the resolution available on many desktop printers. The same material was also printed at a resolution of 1270 dpi—high enough for good-quality printing.

STRENGTH

You can thumbnail, lay out, comp, finalize, and even produce the actual publication within your system. In addition, adjustments and corrections to type or graphics can be made quickly at any stage.

SPEED Desktop publishing has dramatically changed the way publications and camera-ready layouts are produced. Using an electronic page makeup program, such as PageMaker, DesignStudio, or QuarkXPress.

STRENGTH

You can thumbnail, lay out, comp, finalize, and even produce the actual publication within your system. In addition, adjustments and corrections to type or graphics can be made quickly at any stage.

Using the computer, you can prepare exciting live presentations that include video, sound, scanned images, slides, animation, graphic elements in motion, and much more. What you need to do is store your information on a disk and then transfer the presentation to another computer or to special projection or display equipment.

One advantage of a computer presentation is that, with a click of the mouse, you control the sequence and speed of the "show." You can also change the order, if needed, returning or advancing to specific topics. In general, computer multimedia presentations enliven the material and can be much more engaging for an audience than static print mockups. For example, with a computer you can present a chart with the information changing before the viewer's eyes, or you can simulate an object moving in three-dimensional space.

To dramatically convey your client's point, you can choose from a variety of attention-grabbing effects. For example, you might show images of live people on the screen who talk directly to the customer. Or you can combine an animated sequence with background music and narration. You can even create movies that run by themselves.

Desktop Video

Desktop computers can be used during all phases of video production from planning to editing for advertising presentations, animatics, industrial tapes, or commercial broadcasts. However, because desktop video is still an expensive and evolving technology, it is mostly used by companies that produce video projects to be reused many times and thus benefit from being able to store the information electronically. Also, since sound and color take up a tremendous amount of space on disk, videos are usually no more than 22 minutes long.

To produce desktop videos, you need a computer with specific system capabilities and video equipment, including special hardware and a color monitor. In addition, to translate television video signals into the Macintosh video display, special circuiting is needed to synchronize the signals. Other special features are required for laying computer text or images over full-motion video.

To record a video, you must use video cameras that will serve your specific purpose. For example, handheld camcorders suffice for shooting medium-quality videos for presentations. Handheld camcorders should include a zoom lens, a multiple-speed shutter, and a rechargeable battery. You should also be able to connect the equipment to your television for playback. To shoot commercial-quality videos, you need more sophisticated equipment.

Producing desktop video is much like creating an animatic (though with computers you can thumbnail directly on screen). You begin by outlining your ideas with a script or a storyboard and then planning the music, graphics, narration, and sets. The computer storyboard can be animated to further develop the video sequences for shooting. Then the completed video is recorded on a master tape.

In addition to creating moving images, with desktop video you can freeze and digitize still images for use

with graphics and text. With image-editing software you can isolate a single video frame with a digitizer (see page 121) and manipulate or retouch it as if it were a scanned photograph. You can even display video images from live television in a window on the same monitor as your software. This feature allows you to synchronize graphics and text with video clips.

For making a final edit list and master tape, desktop systems offer tremendous speed and flexibility. In particular, they eliminate the problem of muddling through countless pieces of film cuts. The computer provides access to specific frames that are marked with time codes for visual reference to the master tape. When arranging footage on a disk, you can view the results at once.

For a simple presentation, graphs like these can easily be put together from templates available on certain computer programs. With the help of a film recorder or slide service bureau, this material can be output in slide form.

One of the most exciting developments in the graphic arts industry today is *electronic prepress,* where most of the prep work for printing is done on the computer. Electronic prepress offers project turnaround times that were simply not possible before. Now retouching, stripping, proofing, and film separations can be done in a matter of days rather than weeks.

Traditionally, to prepare material for printing, the graphics studio provides camera-ready mechanicals and original artwork and photographs to a color separator or a printer, who then has to manually strip a color separation or halftone into the page negative before printing. Today, film stripping can be bypassed using a desktop system. You can compose full pages including color images and send the file to a prepress service for separations.

There are several electronic prepress systems that convert original art or copy into digital information for high-resolution output. A Scitex system, for example, is composed of a page assembler, color retoucher, line art and color scanner for input and ouput, color thermal proofer, and desktop interfacer. The electronic scanners digitize continuous-tone color transparencies or black-and-white art and then convert the information into pixels. The assembler organizes complete pages consisting of any combination of line art or copy and flat tints. Once an image has been digitized, the system can plot film into full-page four-color separations for printing, retouch and enhance continuous-tone images, or create special effects.

Color retouch stations, also called *imagers,* can create amazing effects with continuous-tone color photographs and transparencies. By typing in commands and using a mouse, the operator can alter or correct color in any area of an image, intensifying colors, or adjusting midtones, highlights, textures, silhouettes, and shadows.

The system can also clone an image or merge images together. For example, an agency may want to combine two separate transparencies into one photographic image. Suppose there is one photo of a boat with no background and another photo of a water scene. Using Scitex, they can combine the images and place the boat in the water. Scitex's image-altering capabilities are limitless. You can erase years from someone's face, add clouds in a sky, give haircuts, or add purple to a white background. With Scitex, if an agency doesn't have the perfect photograph, they simply create it.

Macintosh users can interface with a Scitex prepress service through its Visionary Gateway. The beauty of this interactive system is that the design studio and prepress service can send electronic mechanicals and reference scans of original color transparencies back and forth. You provide the prepress service with original color continuous-tone images, which they convert into full-resolution scanned images before giving you color proofs. After your page layouts are complete, you transmit them directly to the Scitex service, which separates and strips the page elements together. These same pages can be passed back to you through the system for further modifications or approvals.

Bibliography

General

Aldrich-Ruenzel, Nancy, ed. "Designer's Guide to Outfitting the Studio." *Step-by-Step Graphics*, vol. 5, no. 2, 1989.

Laing, John, and Rhiannon Saunders-Davies. *Graphic Tools and Techniques*. Cincinnati: North Light Books, 1986.

White, Jan V. *Graphic Design for the Electronic Age*. New York: Watson-Guptill Publications, 1988.

Type

Aldrich-Ruenzel, Nancy, and John Fennel, eds. *Designer's Guide to Typography*. New York: Watson-Guptill Publications, 1991.

Binns, Betty. *Better Type*. New York: Watson-Guptill Publications, 1989.

Brown, Alex. *In Print: Text and Type in the Age of Desktop Publishing*. New York: Watson-Guptill Publications, 1989.

Carter, Rob; Ben Day, and Philip Meggs. *Typographic Design: Form and Communication*. New York: Van Nostrand Reinhold, 1985.

Craig, James *Designing with Type*. Rev. ed. New York: Watson-Guptill Publications, 1980.

Haley, Allan. *ABC's of Type*. New York: Watson-Guptill Publications, 1990.

Solomon, Martin. *The Art of Typography*. New York: Watson-Guptill Publications, 1986.

White, Alex. *How to Spec Type*. New York: Watson-Guptill Publications, 1987.

Production

Aldrich-Ruenzel, Nancy, ed. *Designer's Guide to Print Production*. New York: Watson-Guptill Publications, 1990.

Bann, David. *The Print Production Handbook*. Cincinnati: North Light Books, 1985.

Beach, Mark; Steve Shepro, and Ken Russon. *Getting It Printed*. Portland, Ore.: Coast to Coast, 1986.

Binns, Betty, with Sue Heinemann. *Designing with Two Colors*. New York: Watson-Guptill Publications, 1991.

Craig, James. *Production for the Graphic Designer*. 2d ed. New York: Watson-Guptill Publications 1990.

International Paper Company. *Pocket Pal*. New York: International Paper Company, 1983.

Sanders, Norman. *Graphic Designer's Production Handbook*. New York: Hastings House, 1982.

S. D. Warren Company. "Varnish Techniques." Boston: S. D. Warren Company, 1986.

Pasteup

Buchan, Jack. *Studio Secrets for the Graphic Artist*. Cincinnati: North Light Books, 1986.

Davis, Susan E. *59 More Studio Secrets for the Graphic Artist*. Cincinnati: North Light Books, 1989.

Demoney, Jerry, and Susan E. Meyer. *Pasteups and Mechanicals*. New York: Watson-Guptill Publications, 1982.

Presentations

Fogle, James, and Mary E. Forsell. *Comps, Storyboards, and Animatics*. New York: Watson-Guptill Publications, 1989.

Marquand, Ed. *Graphic Design Presentations*. New York: Van Nostrand Reinhold, 1986.

New Technology

Dayton, Linnea, and Michael Gorney. *The Verbum Book of Electronic Page Design*. Redwood City, Cal.: M&T Books, 1990.

Gorney, Michael, Linnea Dayton, and Jane Ashford. *The Verbum Book of PostScript Illustration*. Redwood City, Cal.: M&T Books, 1990.

Meyerowitz, Michael, and Sam Sanchez. *The Graphic Designer's Basic Guide to the Macintosh*. New York: Allworth Press, 1990.

Glossary

AA (Author's Alteration): abbreviation denoting a change or addition in typeset copy made by the author or editor. Also called *AC* (British).

AC (Author's Correction): (British) *see* AA (Author's Alteration).

Agate: unit of measurement; 14 agate lines equal 1 inch.

Animatic: art filmed with a video camera to simulate a television commercial. Used for presentation to a client.

Art: illustrative material such as photographs or drawings to be reproduced. Also, broadly, any copy for reproduction.

Artwork: (British) *see* Mechanical.

Ascender: portion of a lowercase character that extends above its x-height, as in *b, d, h,* or *k.*

Author's Alteration: *see* AA.

Baseline: imaginary horizontal line at the foot of the x-height on which the base of the typeform rests.

Bleed: printing an image beyond the edge of a page's trim marks so that the printed image fills the trimmed sheet. For an image to bleed, it should extend ⅛ inch (3 mm) beyond the trim line on the mechanical.

Blind blocking: (British) *see* Blind stamping.

Blind embossing: printing process by which an image is raised on the paper without the use of ink.

Blind stamping: printing process using die without foil to create a debossed effect. Also called *blind blocking* (British).

Blueline: photoprint for proofing, made by a printer from a negative. The copy and images may be blue or brown in color. Also called *blues, Vandykes, brownlines, ozalids, diazos,* or *dyelines.*

Body copy: primary text matter, as distinct from display copy.

Bold: heavy-weight type.

Brownline: *see* Blueline.

Burnish: to rub the top of a surface with a firm, smooth instrument to adhere art or copy.

Camera-ready copy: type or art that is ready to be photographed or scanned for printing. A camera-ready mechanical has been marked with instructions for the printer.

Caps: capital letters, as opposed to lowercase letters. Also called *uppercase* letters.

Caption: text that describes an illustration.

Casting off: converting the character count in a manuscript into a determination of the amount of space the copy will fill when typeset in a certain typeface, size, and measure.

Central processing unit (CPU): main "thinking" component of a computer.

Character: any letter, number, punctuation mark, symbol, or figure in copy.

Character count: number of characters a body of text contains.

Chrome: color transparency.

Coated stock: paper where the surface has been specially treated to improve the finish.

Color separation: use of color filters in a camera or an electronic scanner to break the colors within an image down into dots of yellow, magenta, cyan, or black. During printing, the separations are combined to give the illusion of a full-color image.

Combination shot: image that is reproduced in part as line and in part as halftone. Also called *double burn* (British).

Comp (comprehensive): tightly rendered finished layout that indicates how the final printed piece is meant to appear.

Compositor: typesetter.

Continuous-tone art: photographs or illustrations that contain a range of tones from dark to light, as distinct from line art.

Copy: any art or text matter used for typesetting or printing.

Copy casting: *see* Casting off.

Copyfitting: counting characters and casting off to calculate the amount of space required.

Crop marks: rules drawn on border of art or an overlay to indicate where it should be trimmed. Also used for *trim marks.*

Cropping: selecting an area within a photograph or illustration to be reproduced and eliminating the rest.

Cut-out: (British) *see* Silhouette.

Debossing: printing process in which an area of the paper is recessed.

Densitometer: an instrument that measures the density of printed color.

Descender: portion of a lowercase letter that extends below its x-height, as in *g, j, p,* or *y.*

Diazo: *see* Blueline.

Die cutting: process of producing cutout shapes in paper or board.

Die stamping: process using dies to create a debossed effect on book covers.

Dingbat: small ornamental design used to emphasize copy or decorate a layout.

Direct positive (DP): photostat made without an intermediate paper negative.

Display type: type that is larger than body copy, usually 18 points or larger. Often used for headlines.

Dot gain: tendency for the dots within a halftone to increase in size on press.

Dots per inch (dpi): measure indicating a computer printer's resolution.

Double burn: (British) *see* Combination shot.

Double truck: (British) *see* Spread.

Drop cap: initial cap where the top aligns with the top of the text.

Drop out: instruction to printer to mask an area so that only the paper color will print in this area. Also referred to as *knock out* or *reverse out.*

Dropout halftone: halftone in which the dots have been deleted in the highlights, leaving pure white areas.

Dummy: page-by-page layout indicating the position of type and art elements within a design.

Duotone: halftone printed in two colors, made from a black-and-white photograph.

Dyeline: *see* Blueline.

Electronic prepress: preparation of art and type separations for printing on a computer system.

Electronic scanning: process used to make four-color separations, in which the material is exposed to a high-intensity light or laser beam and the information is analyzed by a computer.

Em: unit of type measure equal to the square of a type's point size.

Embossing: printing process by which an area is raised on the front surface of the paper.

En: unit of type measurement equal to half an em.

Extract: excerpted material, such as a quotation, set off from the rest of the text.

Flat color: solid color produced by a printing ink; usually in distinction to *process color*. Also called *match color*.

Flat tone: area with a single value (without gradations), comprised of evenly spaced and sized dots. Also called a *tint.*

Flexography: printing process related to letterpress, using rubber or photopolymer printing plates. Widely used for packaging because it is possible to print on surfaces such as plastic and metallic film.

Flop: to create a mirror image.

Flush type: type aligned evenly with the left or right margin.

Folio: page number.

Font: all the characters of one size of a typeface, including letters, numbers, fractions, punctuation marks, and symbols.

For position only (FPO): notation indicating that an image on a mechanical is a reference for position, but should not be used for reproduction.

Four-color process: reproduction method in which a full-color image is separated into dots of red (magenta), yellow, blue (cyan), and black. Four printing plates are then made; when printed together they reproduce the full-color original.

FPO: *see* For position only.

Galley: typeset proof provided by a compositor for proofreading and use with layouts.

Gang: to group art to be enlarged or reduced the same amount so that it can be shot together, as one shot.

Ghosted halftone: halftone that is shot as a percentage of the original's tones, making it much lighter.

Gravure: printing process in which the image areas are etched into the printing plate. When the plate is inked and wiped clean, only the etched areas print.

Greeking: indicating type in a layout by simulating the shapes of letters without using real words.

Haberule: type gauge with measures for different amounts of line spacing, from 6 to 15 points, as well as measures for picas, agates, and inches.

Hairline rule: very thin rule, ¼ point wide.

Halftone: continuous-tone image scanned or photographed through a

139

screen to translate the tones into tiny dots of differing sizes. These dots can be seen through a magnifying glass in the reproduction, but when viewed at normal range, they blend together, suggesting continuous tone.

Hanging indent: indent where the first line runs the full width and subsequent lines are indented.

Headline: primary line of type giving the title of the text or simply grabbing the reader's attention. Usually set large, in display type.

Highlight halftone: *see* Dropout halftone.

Holding line: red or black rule indicating to the printer the exact area in which art is to be placed. Also called a *keyline*.

Initial cap: large uppercase letter beginning a block of text.

INT: short for Letraset's Image'n Transfer, a product that allows you to transform your own line art into pressure-sensitive sheets like those used for transfer lettering.

Italic: type that slants to right.

Justified type: copy block that aligns flush on both the left and the right.

Kerning: lessening the space between certain letters to make the letterspacing appear consistent.

Keyline: see Holding line.

Knock out: *see* Drop out.

Layout: preliminary drawing made to plan the positioning of art and type elements for a final design. Specifically referred to as *thumbnail*, *rough*, or *comprehensive*. Also used to refer to overall design.

Lead-in: type of head in which the first words of the text are set off in a different type style, such as bold or italic.

Leading: space between lines of typeset matter. Also called *line spacing*.

Letterpress: printing process in which the surface to be printed is raised and then inked and pressed onto the paper. Also called *relief printing*.

Letterspacing: space between characters in a typeset word.

Ligature: two letters that are joined together to form a unit.

Line art: art that is only black and white without any gradations of tone.

Line conversion: process using a special-effects or halftone screen to change tone art into line art.

Line spacing: *see* Leading.

Lowercase: small letters, as opposed to *caps*.

Machine proof: (British) *see* Press proof.

Masking film: plastic sheet with transparent red (Rubylith) or amber (Amberlith) film used as a guide for the printer in blocking out an area on a mechanical or image.

Match color: *see* Flat color.

Measure: length of a line of type.

Mechanical: assembly of all camera-ready type and art in position for the printer on base board and attached overlays. Also called *artwork* (British).

Minus leading: specification of

less space between lines than with type set solid.

Modem: (*mo*dulator/*dem*odulator) device changing signals to transmit information with different kinds of equipment—for example, to send computer information over phone lines.

Moiré: distracting pattern caused by incorrectly overprinting two screened areas.

Offset lithography: common printing process using a flat surface treated with chemicals so that the image areas accept ink and the other areas repel it.

Outline halftone: *see* Dropout halftone.

Overlay: transparent or translucent sheet of acetate, tissue, or layout paper placed over copy, art, or a mechanical to protect it, convey instructions to printer, or separate copy to be surprinted.

Overprint: (British) *see* Surprint.

Ozalid: *see* Blueline.

PANTONE® MATCHING SYSTEM (PMS): brand name for most widely used color-matching system, offering about 750 color choices for inks.

Pasting up: the process of adhering camera-ready copy on a mechanical board.

PE (Printer's error): abbreviation denoting a change in typeset copy caused by the typesetter's error. The client never pays for PEs.

Photomatic: video presentation simulating a live television commercial that consists of a series of cutout photographs videotaped in sequence.

Photostat (stat): black-and-white photoprint made from an original photograph or other art. Used to indicate the size and position of original art in the layout; sometimes used as line art.

Phototypesetting (photocomposition): process of setting type matter onto photosensitive film or paper.

Pi characters: special typeset symbols such as accented letters or mathematical and reference signs.

Pica: unit of type measurement; 1 pica contains 12 points and equals about ⅙ of an inch.

Pixel: *pic*ture *el*ement on a computer; the smallest element composing a computer image.

PMS: see PANTONE MATCHING SYSTEM.

Point: unit of type equal to ¹/₁₂ of a pica and approximately ¹/₇₂ of an inch.

Posterization: special effect in which continuous-tone copy is converted into high-contrast line art.

Prepress proof: proof made from screened separations before the plates are made, used by the client to check a job before it goes on press.

Press proof: proof made on a press, often a smaller press than that used for printing. Also called *machine proof* (British).

Ragged type: block of type set so that lines do not align evenly along the left or right edge.

Register marks: crosses, circles, or similar marks placed on the base mechanical and any overlays to guide the printer in accurately aligning two or more superimposed type or art elements.

Registration: printing two or more superimposed type or art elements in exact alignment with each other.

Relief printing: *see* Letterpress.

Reproduction house: (British) *see* Separator.

Reproduction proof (repro): high-quality camera-ready typeset copy used on a mechanical for reproduction.

Reverse: to transpose black and white areas, making negative areas positive and vice versa.

Ripamatic: *see* Stealamatic.

Roman: type with upright letters as opposed to *italic*.

Rough: preliminary layout used to plan the overall design of type and art.

Rubylith: trade name for red masking film.

Runaround: type that wraps around other type or an illustrative element, following its contour.

Sans serif: without serifs. *See* Serif.

Scaling: determining the correct proportions of art for enlargement or reduction.

Scanner: instrument used to copy original black-and-white or color art into a computer. *See also* Electronic scanner.

Scitex: brand name of an electronic prepress system.

Scotch rule: decorative rule that consists of two or more parallel lines of different point sizes.

Screen: sheet of glass or film containing a series of dots or lines through which continuous-tone art is photographed to obtain a halftone.

Screen printing: printing process in which ink is forced by a squeegee through porous silk or similar material containing a stenciled image. Also called *silkscreening*.

Separator: firm that prepares film for printing, particularly four-color separations; often distinct from printer. Also called *reproduction house* (British).

Serif: "tail" that trails off the strokes of letters.

Set solid: type set with the same space between lines as the type's point size.

Sheet-fed press: press that uses individual sheets of paper.

Silhouette halftone: halftone in which an image is outlined and any background is removed. Also called a *cut-out* (British) or *outline halftone*.

Small caps: caps designed to be the same size as the x-height of a lower-case letter.

Spotting: elimination of white dots on black-and-white photographs using special photographic dyes.

Spread: two facing pages. Also called *double truck* (British).

Square halftone: halftone trimmed as a square or rectangle.

Stamping: printing method using dies to impress an image. Most often used to create a debossed effect on book covers.

Stat: *see* Photostat.

Stealamatic: video presentation simulating a live television commercial created from off-line videotape.

Storyboard: series of layout frames that indicate the action for a video or television commercial.

Stripping: combining several negatives of art or type into a single negative with each element in correct position for reproduction.

Subhead: line of type of secondary importance to the title or headline.

Surprinting: printing over an area that has already been printed. Also called *overprinting* (British).

Text type: primary body type.

Thumbnail: small, cursory sketch usually used as the first step in planning a design.

Tint: *see* Flat tone.

Transfer lettering: letterforms on pressure-sensitive, self-adhesive sheets that can be transferred to a flat surface.

Trapping: printing technique in which two discrete color areas overlap slightly so that a white line doesn't appear in between.

Trim marks: crop marks on mechanical indicating where paper edge should be.

Trim size: final size of a finished printed piece.

Typeface: particular design of an alphabet.

Type family: styles of a particular typeface including its various weights (light to heavy) and postures (vertical or slanted).

Type gauge: instrument used to calculate leading during the copyfitting process. *See also* Haberule.

Uppercase: capital letters.

UV-cured coating: varnish dried by ultraviolet radiation, used as a protective coating for the printed piece.

Varnishing: finishing process

adding a glossy or matte protective coat to the printed piece.

Velox: positive photographic paper print made from shooting continuous-tone art through a screen. Can be used as line art directly on a mechanical.

Vellum: high-quality translucent tracing paper used for ink renderings and overlays.

Video digitizer: instrument that converts images from video sources such as video cameras and VCRs into still digital images.

Vignette halftone: halftone in which the edges blur or fade away gradually.

Web-fed press: press that uses rolls of paper.

Word spacing: spacing between words.

x-height: height of a lowercase "x"; more generally, the body of any lowercase letter, not including an ascender or descender.

Index

INDEX